POSTCARD HISTORY SERIES

Boise

ON THE FRONT COVER: VIEW FROM CAPITOL DOME. Downtown Boise is seen from the capitol dome before 1931. The building to the right of the structure with the Standard Furniture sign was replaced with the Hotel Boise, which is now the Hoff Building. The Hotel Boise was completed in 1930–1931. (Author's collection.)

ON THE BACK COVER: NEW STATE CAPITOL, 1920. The new state capitol is seen around 1920. The center section of the capitol was started in 1906, and the wings were added in 1920. Both automobiles and horses are on the street. (Author's collection.)

POSTCARD HISTORY SERIES

Boise

Frank E. Aden Jr.

ARCADIA
PUBLISHING

Published by Arcadia Publishing
Charleston, South Carolina

Printed in the United States of America

Library of Congress Control Number: 2014941127

For all general information contact Arcadia Publishing at:
Telephone 843-853-2070
Fax 843-853-0044
E-mail sales@arcadiapublishing.com
For customer service and orders:
Toll-Free 1-888-313-2665

Visit us on the Internet at www.arcadiapublishing.com

I wish to dedicate this book to my parents, Frank and Lela Aden. I also dedicate this book to all who consider themselves Boiseans.

CONTENTS

ACKNOWLEDGMENTS

Around 1970, when I was in high school, I was given an old postcard of Boise. I was intrigued about how much the view had changed. From that time, whenever I went to an antiques store or a postcard or stamp show, I looked for old postcards of Boise. I was amazed about how many I found, even in cities outside the area when I went on trips. When online auctions became available, I checked every day to see if Boise postcards were available. Eventually, I found I had amassed over 300 postcards of Boise alone and realized that what I had was a very important record of Boise history. I thought that it would be great to make them available to historians of Boise in a book. I am grateful that Arcadia Publishing has made this possible. Unless otherwise noted, all postcards in the book are from the author's collection.

I would like to thank the following, who have helped me locate, identify, and research the postcards included in this book: Larry Adams, Mark Campbell, Bill Frahm, Art Gregory, Al Hale, Terry Hine, and my father, Frank Aden Sr.

I would also like to thank Dr. Peter Reedy and in memoriam Dr. Paul Ryan and Dr. William Vinning. Without them, this book would not have been possible.

INTRODUCTION

When people think of the Wild West, they imagine places like Tombstone, Dodge City (really a Midwest town), and Deadwood. Our perceptions have been influence by movies and television. The reality is much more interesting, and many towns and cities of the Old West do not always come to mind when the topic comes up. Boise is a perfect example of such a town.

The city was founded on the Oregon Trail in 1863, after the opening of the second Fort Boise. The fort was established to protect the miners who had flocked to the Boise Basin after the discovery of gold near Idaho City. Many more of these miners came from the west than from the east. Boise became the largest city on the Oregon Trail, not counting the trail's terminus cities, and it remains so today. Prior to the founding of Fort Boise, the area was explored by fur trappers; it was they who really opened the area for further expansion.

Boise became an oasis on the Oregon Trail, established just south of the fort and just north of the Boise River. As the city grew, the Boise River made the region a strong agricultural area, with farms and ranches nearby. Many of the original sites are now well within city limits.

By 1864, Boise was the major financial center (even though still small) of the Idaho Territory, with the capital having been moved from Lewiston. For many, this is still a very controversial decision. By the late 1880s, Boise had a substantial downtown. After 1900, many multistoried buildings were erected. Passenger train service came to Boise in 1888 after a branch line was built from Nampa. The main line missed Boise, running from Mount Home to Kuna, then to Nampa, south of Boise.

Starting in the late 1800s, local farmers began diverting water from the Boise River in small canals. After 1900, small dams were built east of Boise that were used to divert water into permanent canals, such as the New York Canal, which runs from the Diversion Dam to Lake Lowell, south of Nampa. This made it possible for the expansion of farming and ranching in the Boise Valley, which helped the isolated town support itself.

By the 1920s, downtown Boise was the commercial center of the west Boise Valley. Downtown was home to the area's grocery, clothing, and furniture stores and was the center for doctors' offices and pharmacies. Albertsons opened its first supermarket west of downtown, on Sixteenth and State Streets, in 1939, and many of the drugstores and grocery stores moved to the Boise Bench. Department stores, both local and national, were also centered downtown. Today, there are no major department stores or grocers in immediate downtown Boise. There were several theaters in downtown Boise until the mid-1960s. Of the original theaters, only the Egyptian exists today.

At the end of the 1960s and through the 1970s, Boise suffered urban renewal. Many buildings, including some historic structures, were torn down for a planned downtown mall. Many of Boise's department stores had planned to move to the new mall with greatly expanded retail

space. The downtown mall never got built, leaving many open lots where buildings had once stood. Many of these lots remained empty for years, making downtown look like a war zone, as one magazine commented. Starting in the mid-1970s, these lots were slowly filled in, with many turned into parking lots that remain today. Boise finally got its mall in 1988, on the bench, at Cole and Franklin Roads, the former location of a farm.

Downtown Boise had been the center of commerce for many years, but, with the expansion of the city into the valley and up onto the benches, many of the major highways coming into town, such as US 30, began to attract businesses. Some of the downtown retailers began to move to the new strip malls on these roads, turning them into major thoroughfares. Strip malls started to attract customers from downtown with their free parking. The first was Vista Village on Vista Street, built in 1949. Opened in the early 1960s, Hillcrest Center at Orchard Street and Overland Road, bringing new retailers to the valley. Streets like Fairview, Broadway, State, Overland, and Chinden (Garden City) became commercial retail centers. Downtown had several national five-and-dime chain stores, such as Kress, Woolworth, and Newberry. Woolworth moved to Hillcrest Center for a few years, then to Karcher Mall in Nampa. Kress went out of business in 1981, and Newberry and Woolworth followed in 1997. Karcher Mall opened in Nampa in 1965. It was the largest mall in the area until Boise Towne Square opened in 1988. It was also the first enclosed mall in the area. J.C. Penney continued to maintain its downtown store, offering mainly clothes and a catalog order desk. When it opened its Karcher store, it was the first full-line J.C. Penney in the state. The freeway (I-80 North, later renumbered I-84) had come to the Boise Valley in the early 1960s, making it easy for people in Boise to drive to Karcher Mall. Since the opening of Boise Towne Square, Karcher has struggled to survive.

As the years have gone by, the Boise Valley has become one big city. Boise, Meridian, Nampa, Caldwell, Garden City, and Eagle have begun to run together. The US Census Bureau now considers the area the Boise-Nampa Metropolitan Area, with over 650,000 people at the time of this writing. This is quite a change from the little frontier towns they once were.

One

MAIN STREET

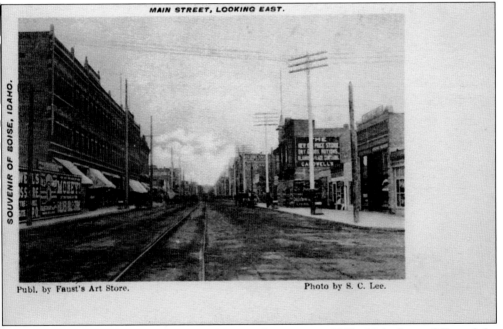

MAIN STREET, LOOKING EAST.

SOUVENIR OF BOISE, IDAHO.

Publ. by Faust's Art Store. Photo by S. C. Lee.

MAIN STREET, LOOKING EAST FROM TENTH STREET, C. 1900. Main Street followed the
Oregon Trail route through what is now downtown Boise, which was partly on Cottonwood
Creek. This is where the first businesses started, which helped to service the travelers on the
Oregon Trail and the gold prospectors headed to the Boise Basin. This is one of the earliest
postcards of Boise, issued just after the Private Mailing Card Act of 1898. The fence at left marks
construction of the Idanha Hotel, completed in 1901. Next to it are the Golden Rule Building
and the Sonna Building, erected in 1888 and expanded in 1891 and 1895. Across the street is a
group of buildings, all of which were torn down in the early 1970s as part of the Boise urban
renewal project—except for the building with the spire, which burned down in 1924. Located
about midway between Fort Boise and the Boise River, this is where Boise really got its start.

9

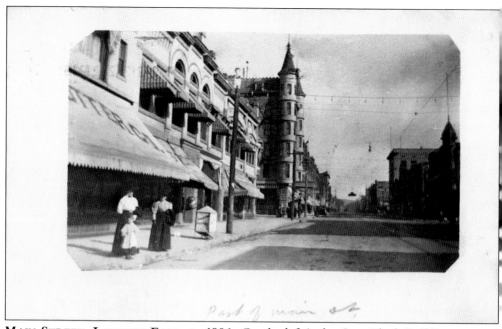

Part of main st.

MAIN STREET, LOOKING EAST, C. 1906. On the left is the Gem Block Building, erected around 1902. On the corner is Joy Drug. The Idanha Hotel is next on the left side. This card is postmarked April 12, 1909. Small lightbulbs are hung from a wire crossing the street. This method was used before electrified lampposts were installed.

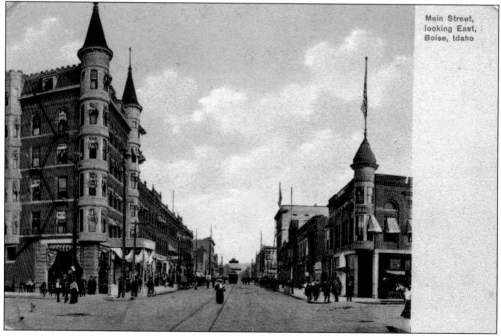

Main Street, looking East, Boise, Idaho

MAIN STREET, FROM TENTH STREET, C. 1909. Next to the Idanha Hotel (in the center of the block) is the Goldenrule store (the sign is just visible). It later became J.C. Penney. Today, the location is a parking lot. All of the buildings on the south side are gone. This postcard with an east-facing view is postmarked May 31, 1910.

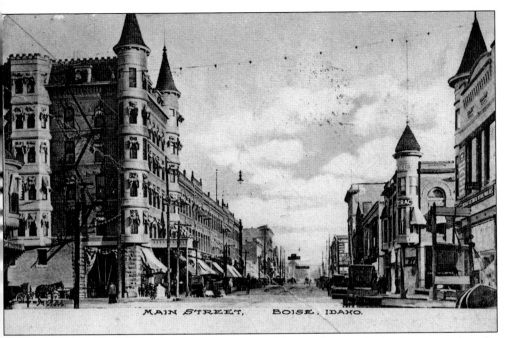

MAIN STREET, LOOKING EAST, C. 1909. Automobiles can be seen in the distance and on the right in this photograph, taken from Tenth Street. It is believed the first automobiles arrived in Boise in 1906. Signs hanging over Main Street in the distance are for the Columbia Theater, which is seen in other postcards in this book. The card is postmarked 1910.

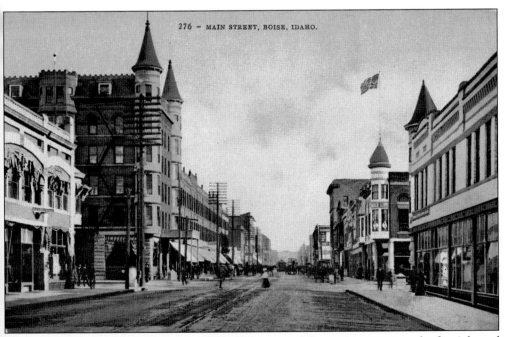

MAIN STREET, LOOKING EAST, C. 1910. This postcard features a wagon on the far right and what is probably a power pole. It is color-tinted.

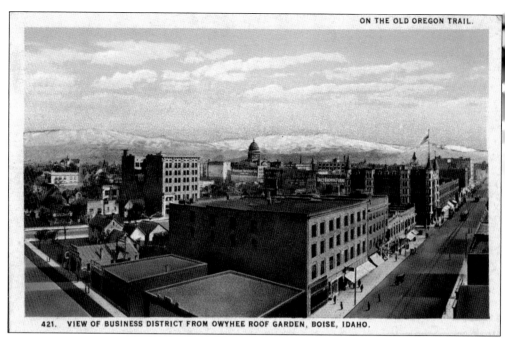

421. VIEW OF BUSINESS DISTRICT FROM OWYHEE ROOF GARDEN, BOISE, IDAHO.

MAIN STREET FROM OWYHEE HOTEL, 1915–1920. In this postcard with an east-facing view, the Alaska Building (center), constructed in 1906, is seen next to the Averyl Building, which housed the Boz Theater. The Alaska Building today is a multi-office facility, and the Averyl Building is now the home of the Bouquet. It is interesting to note the existence of private homes behind the Alaska Building. The homes are gone, and the site is now occupied by office buildings.

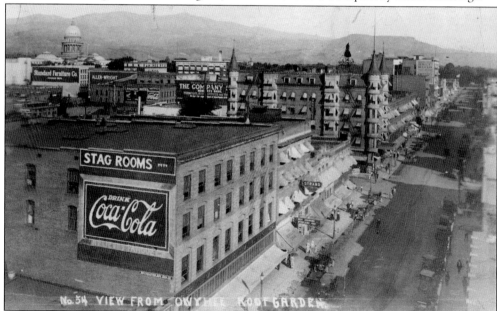

MAIN STREET, LOOKING EAST, EARLY 1920S. In this postcard, the former Box Theatre is now the Strand. The Joy Drug Store sign can be seen on the corner of the Gem Block Building. The Coca-Cola sign is visible here, on the west side of the Alaska Building. The state capitol is seen in the distance at left. This photograph was taken from the top of the Owyhee Hotel.

Two

BOISE INTERURBAN

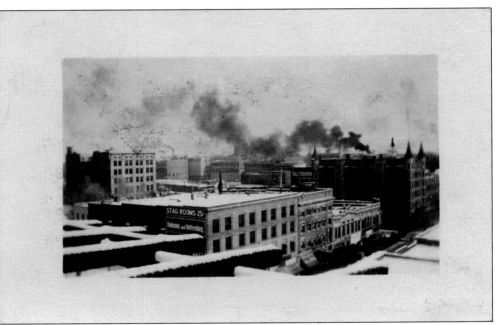

MAIN STREET, 1910–1915. Construction on Boise's trolley system started in 1891. The line eventually ran from downtown Boise, up State Street to Caldwell, down to Nampa, and across to Meridian and then back into Boise. It carried freight and passengers and included covered stations along the way. Automobiles came to Boise in 1906, and, with paved roads, people used the interurban less and less. With the completion of a paved highway to Nampa from Boise in 1928, the interurban shut down, replaced by a transit bus system. The tracks were paved over in many places, and, years after 1928, road crews doing work on Boise streets would come across the buried rails. (For more information on the interurban, see Arcadia's *Treasure Valley's Electric Railway* by Barbara Perry Bauer and Elizabeth Jacox.) Most postcards feature spring and summer scenes, but this card is unusual, as it is a winter image. Snow can be seen on the beams of the Owyhee Hotel roof gardens. Before electric and gas heat became common, coal-fired furnaces were the norm. As seen in this photograph, taken from the Owyhee Hotel, Boise during the cool months was enveloped in smoke.

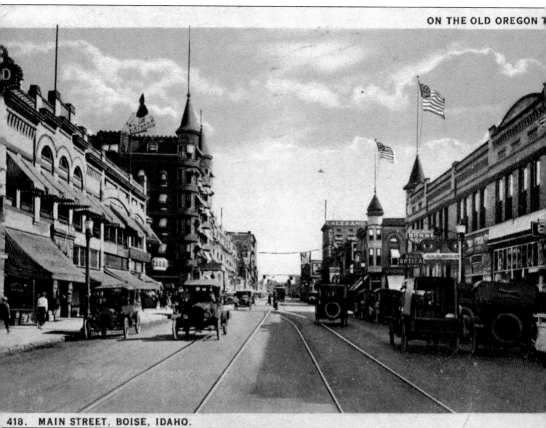

418. MAIN STREET, BOISE, IDAHO.

MAIN STREET, BETWEEN ELEVENTH AND TENTH STREETS, C. 1920S. At the corner of the Gem Block Building, the Joy Drug store sign can be faintly seen. An advertisement for Alexander's Clothing Store is in the distance at right, on the Yates Building. Automobiles are now dominant on the street; no horses or wagons are seen. This card is postmarked 1934.

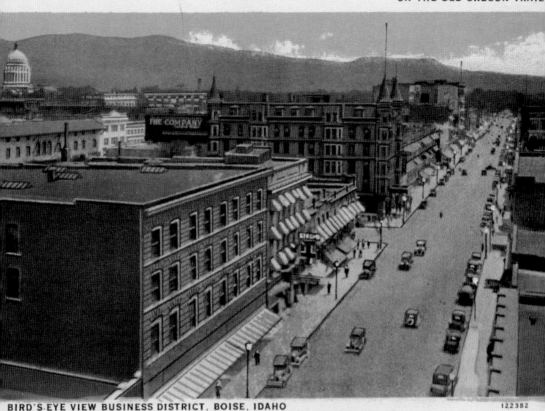

BIRD'S-EYE VIEW BUSINESS DISTRICT, BOISE, IDAHO 122382

MAIN STREET, LOOKING EAST, LATE 1920S. The former Boz Theater is now the Strand, visible in the middle of block, on the north (left) side. The C.C. Anderson Building can be seen with the sloping overhang in the background, on Idaho Street. Built in 1926, it later became the Bon Marché, then Macy's. The building is now empty, waiting for development. This photograph was taken from the top of the Owyhee Hotel.

15

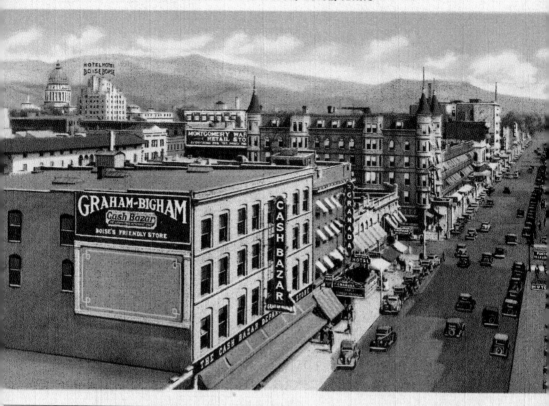

MAIN STREET, FROM TOP OF OWYHEE HOTEL, EARLY 1930S. The interurban tracks are gone in this postcard photograph. The Strand is now the Granada, which was the final name for the theater in the Averyl Building. The Alaska Building (foreground) was the home of one of Boise's most popular department stores, Cash Bazar. On the south side is the Stage Depot, the bus terminal for Union Pacific Stages. Many of the major railroads operated intercity bus service to feed their passenger lines.

Three

BUS LINES

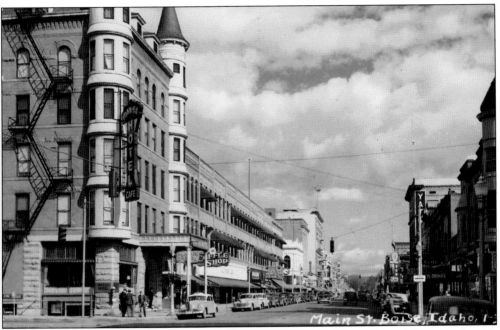

MAIN STREET, LOOKING EAST FROM TENTH STREET, LATE 1940s. After paved roads became common, intercity bus lines sprang up throughout the state. Union Pacific Stages became Overland Greyhound after the government required the railroads to divest themselves of bus lines. Greyhound later opened a terminal on the corner of Ninth and Bannock Streets and then, in the early 1960s, moved to a larger terminal a few blocks to the west. Northwestern Stage Lines ran from Boise to Lewiston and, later, to Spokane—and still does today. Boise Winnemucca ran to Winnemucca, Nevada, and, for a short time, to Reno. It runs only charter service today and is owned by the same family that owns Northwestern. Mount Hood Stages, out of Bend, Oregon, ran from Portland to Bend, then to Boise and later to Salt Lake City. It joined the National Trailways Bus System in January 1943. The company later opened a terminal a few blocks down from the Stage Depot (at far right), then, in 1947, to 315 North Ninth Street. Pacific Trailways passed into bus history in 1988. The Goldenrule Store (on the left) is now J.C. Penney. On the south side is the Boise Theater, originally the Lyric. The Western Bar can be seen at the corner of Ninth Street on the south side. That location is now occupied by the Wells Fargo Building. In the far distance on the north side of Main Street is the Oxford Hotel, built in 1905. The Ada Theater (now the Egyptian) is seen in the distance on the north side.

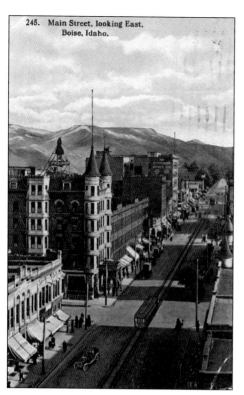

245. Main Street, looking East,
Boise, Idaho.

MAIN STREET, FROM TENTH STREET, C. 1915. In this photograph, taken from the Owyhee Hotel, the Goodman Jones sign on the Eastman Building is seen on the far north side. All of the buildings east of the Sonna Building (next to the Idanha Hotel) are gone. The large neon sign on top of the Idanha Hotel was taken down in the late 1920s. Beyond the Eastman Building is the horse sign on the Pioneer Tent Building. The sign still exists today.

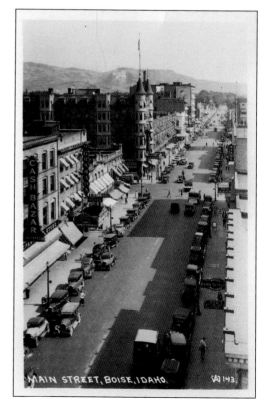

MAIN STREET, LOOKING EAST FROM TENTH STREET, LATE 1920S. The sign on top of the Idanha Hotel is now gone. In the distance is the Fox Theater, originally the Egyptian Theater, built in 1927. It was later called the Ada. Today, it is again named the Egyptian. The W.E. Pierce Building, constructed in 1902, is the location of the Stage Depot. All the buildings on the south side were torn down in the mid-1970s.

18

MAIN STREET, LOOKING EAST. This parade was held in celebration of the coming of the main line of the Union Pacific Railroad. The new train depot was completed at the end of Capitol Boulevard at this time. The photograph for this postcard, postmarked April 1925, was taken from the top of the Owyhee Hotel.

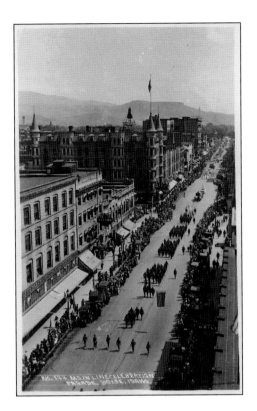

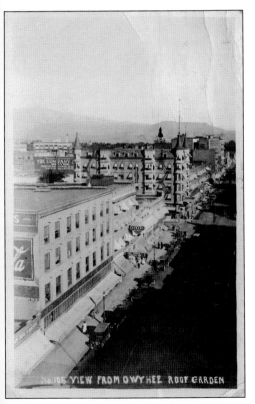

MAIN STREET, FROM THE OWYHEE HOTEL, LATE 1910s. Automobiles now dominate the streets. On the corner of the Gem Block Building is the Joy Drug Store sign, and on the Averyl Building is the sign for the Strand Theater. This card is postmarked 1921.

19

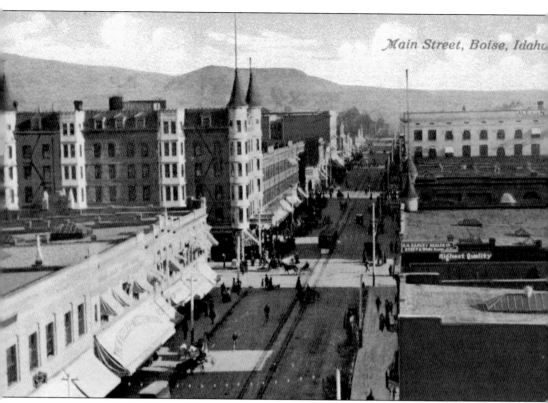

MAIN STREET, LOOKING EAST FROM TENTH STREET, PRE-1910. Both wagons and automobiles can be seen on the street. At right in the distance, Alexander's Clothing Store sign can be seen on the Yates Building. The Alexander's Clothing Store was built across the street in 1927. Its owner, Moses Alexander, served as governor of Idaho. This view is from the Owyhee Hotel.

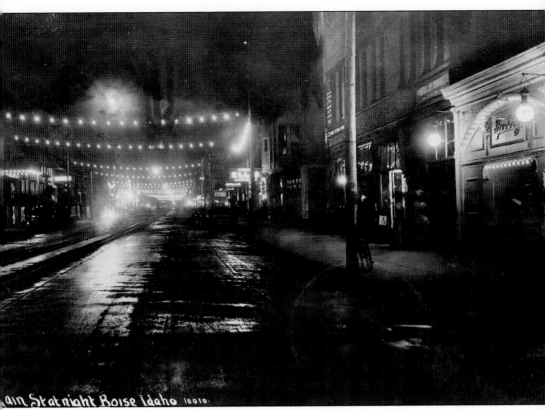

Main St at night Boise Idaho 10010

MAIN STREET, LOOKING EAST, C. MID-1910s. Pictured here is Main Street at night, seen from between Ninth and Tenth Streets. Electric lightbulbs are strung on wires across the street, before electrified lampposts were used. At center on the right is the Mutual Life Insurance Co. This image is unusual, as nighttime scenes were rarely used on postcards.

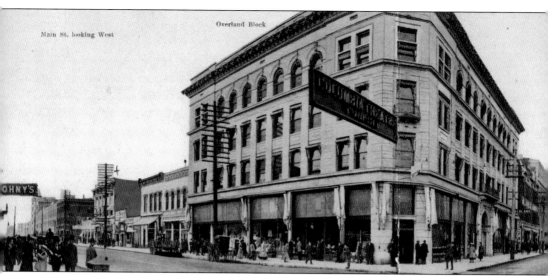

MAIN STREET, POSTMARKED 1909. This is a great panoramic view of Main Street. On the left is the Eastman Building before two floors were added. In the distance are the Idanha Hotel and the Sonna Building, and across the street is the structure replaced with the Alexander Building in 1927. In the center, with a view looking north, is Eighth Street. The only buildings in this

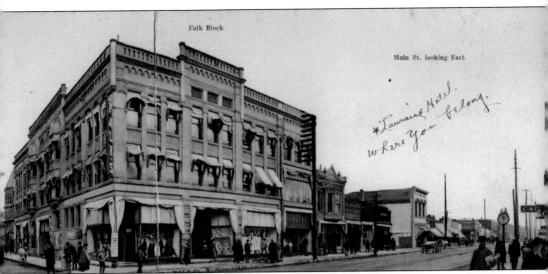

Falk Block

Main St. looking East

*Laurain Hotel. where you belong.

postcard that exist today are the Boise National Bank Building (barely seen on the left) and the Federal Building (distant left). The right side shows the Falk's Building. The rest of the buildings in this view are gone. This may be actually a pre-1906 view, as no automobiles are seen.

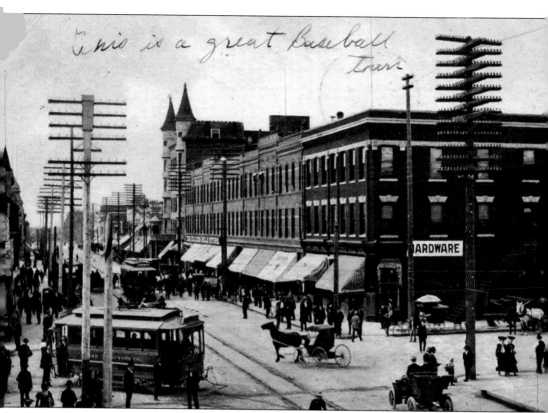

MAIN STREET, LOOKING WEST FROM NINTH STREET, C. 1906. A hardware store sign is seen on the Sonna Building. The Goldenrule sign is visible farther down the block. A car appears on Main Street among horses and buggies, pedestrians, and trolleys. All of the buildings on the left no longer exist. This card is postmarked 1911.

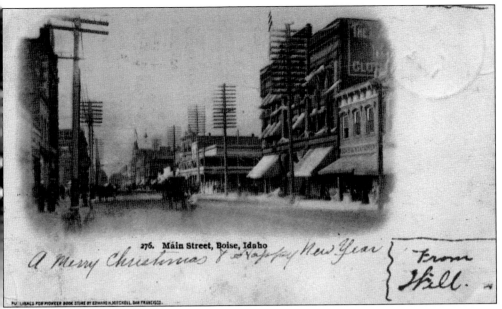

MAIN STREET, LOOKING WEST FROM EIGHTH STREET, C. 1903. Falk's Building is on the north side, and the Overland Hotel is across the street. The Eastman Building replaced it. This postcard, postmarked January 3, 1904, is probably one of the earliest cards issued for Boise. The photograph does not completely fill the card, which has space on the right for writing. All of the buildings across the street, on the south side, were gone by the mid-1970s.

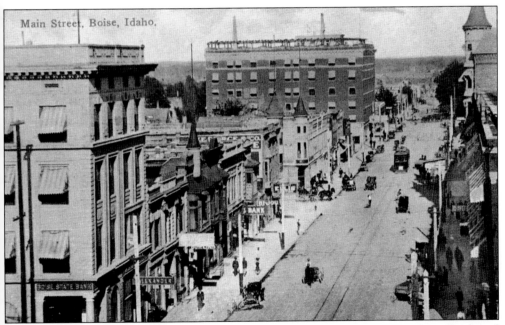

MAIN STREET, LOOKING WEST FROM NINTH STREET, C. 1910. Boise State Bank and Alexander's occupy the Yates Building (left). A large pennant banner is on top of the Owyhee Hotel, which has two smokestacks. Both automobiles and wagons occupy the street. All of the buildings on the left side are now gone.

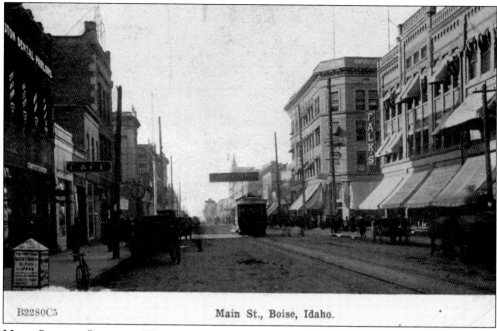

Main St., Boise, Idaho.

MAIN STREET, LOOKING WEST FROM EIGHTH STREET, 1910s. The Columbia Theater sign hangs over Eighth Street. The Falk's Building is to the right. Across the street from it is the Eastman Building. The street is mostly occupied by wagons and horses.

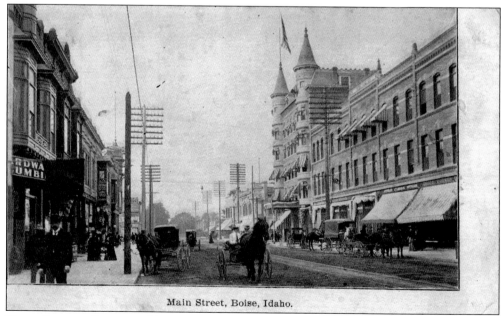

Main Street, Boise, Idaho.

MAIN STREET, LOOKING EAST FROM NINTH STREET, 1901–1906. As no automobiles are present, this postcard predates 1906. It is postmarked 1908. Note the telephone/power poles with multiple cross boards. The Idanha Hotel is in the right center.

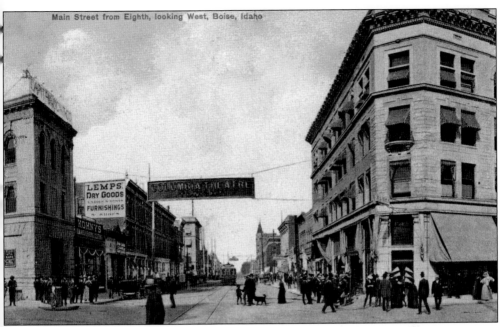

MAIN STREET, LOOKING WEST FROM EIGHTH STREET, C. 1906. The sign hanging over Eighth Street is for the Columbia Theater. The Overland Hotel has been replaced by the four-story Eastman Building. Later, two more floors will be added. At left is a sign for Lemps Dry Goods. John Lemp, a local pioneer, came to Boise in 1863 and served as mayor.

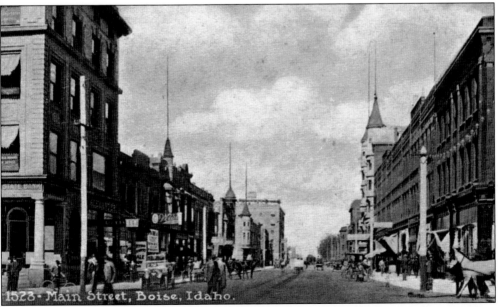

MAIN STREET, FROM NINTH STREET, C. 1910s. In this west-facing view, the Yates Building is on the left and the Sonna Building is on the right. Visible on the far right are lightbulbs on a wire across Ninth Street. Electrified lampposts have yet to be used. An Alexander's sign is on the Yates Building. Horses and automobiles occupy the streets.

27

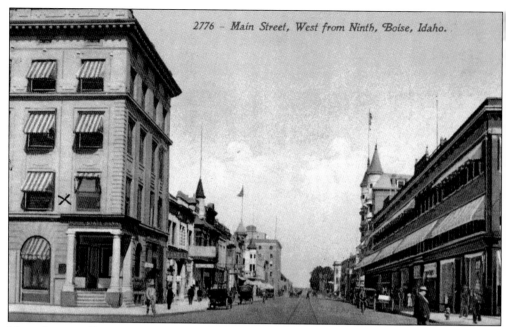

2776 - Main Street, West from Ninth, Boise, Idaho.

MAIN STREET, LOOKING WEST FROM NINTH STREET, PRE-1920. The Yates Building (far left) has Boise State Bank on the near side, and the Alexander's sign is in front. Note the fire hydrant in front of the Sonna Building (right). No horses or wagons are present, only automobiles.

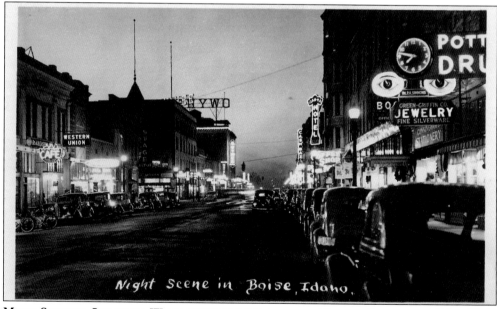

Night scene in Boise, Idaho.

MAIN STREET, LOOKING WEST BETWEEN NINTH AND TENTH STREETS, 1930S. Main Street is a sea of neon signs, which today are only rarely seen. Potter Drug (far right) moved to what was considered the "country," to Orchard Street on the first bench, a few years later. The neon sign on the side of the Owyhee Hotel (at left in the distance) was recently re-created and installed on the building, which is now an apartment complex. The Stage Depot sign at center left is not lit up.

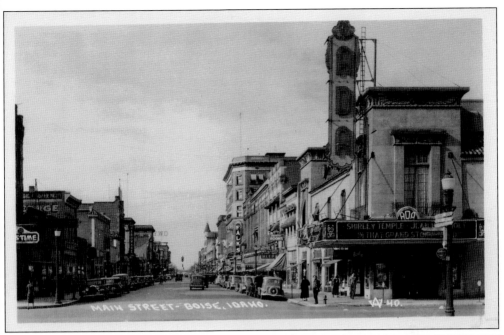

MAIN STREET, LOOKING WEST FROM CAPITOL BOULEVARD, LATE 1930S. The Ada Theater (now the Egyptian) is on the right. Its marquee advertises *Heidi*, starring Shirley Temple, which was released in 1937. On the far left, the sign for the Pastime Bar is partially visible. The Waldorf Hotel is the next building on the block. In the distance is the Owyhee Hotel's large sign on its roof. All of the buildings on the south (right) side of the street, west of the Ada Theater, no longer exist.

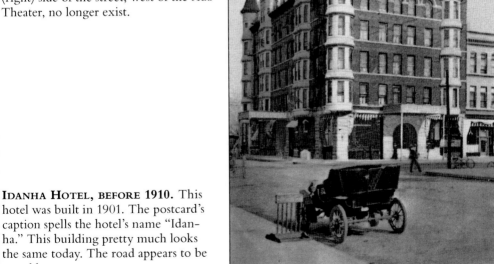

IDANHA HOTEL, BEFORE 1910. This hotel was built in 1901. The postcard's caption spells the hotel's name "Idan-ha." This building pretty much looks the same today. The road appears to be paved here.

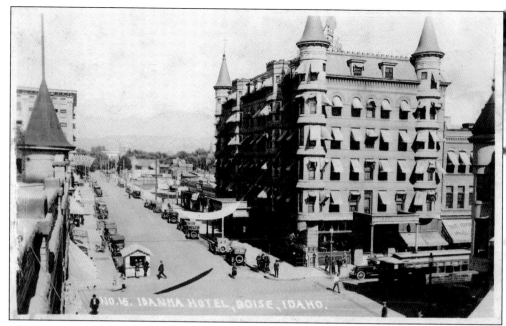

MAIN STREET, 1920s. The Joy Drug sign is at lower left. The Idanha Hotel is on the right. The open area behind the Idanha Hotel became the site of the C.C. Anderson Building, constructed in 1926. The Empire Building is the tallest building on the far left. This postcard, with a view that looks up Tenth Street, is postmarked 1922.

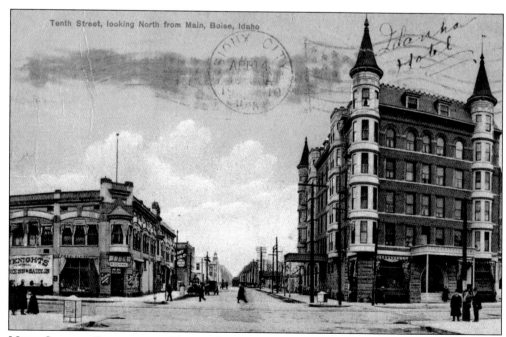

MAIN STREET, LOOKING UP TENTH STREET, EARLY 1900s. In this postcard, postmarked 1910, the Joy Drug Store is on the left, at the corner of the Gem Block Building, constructed in 1902. Above the drugstore's door are signs reading "Drugs" and "Kodaks."

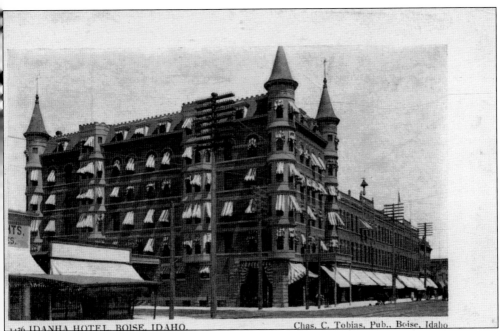

IDANHA HOTEL, BOISE, IDAHO. Chas. C. Tobias, Pub., Boise, Idaho

MAIN STREET, LOOKING EAST, C. 1901. The Gem Block Building has yet to be built in the site at left. This early postcard has space on the right for messages. No automobiles are present, only wagons and horses.

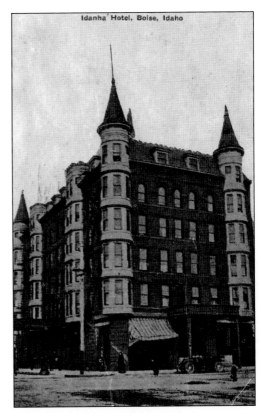

Idanha Hotel, Boise, Idaho

IDANHA HOTEL, C. 1906. This is a very poor-quality view on a vertically polarized card, postmarked 1912. Note the automobile in front.

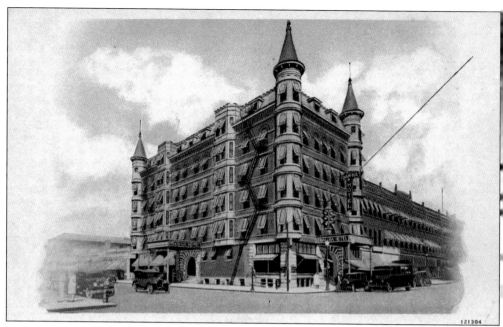

IDANHA HOTEL, C. 1920S. The back of this postcard offers, "When visiting Boise, make your home with us." The structure behind Idanha should be the C.C. Anderson Building, which did not look like what is pictured. This may be a line drawing inaccurately depicting the Anderson Building. This card is either a tinted photograph or a line drawing, or a mixture of both.

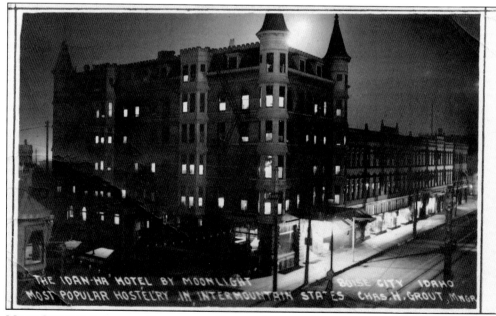

MAIN STREET, LOOKING EAST FROM TENTH STREET, PRE-1910. This nighttime-themed card is postmarked 1909. Night views are rare in postcards. Note that neon signs have yet to be installed. No signs for any of the businesses can be seen.

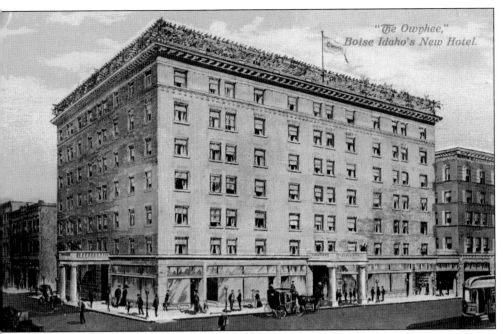

OWYHEE HOTEL, PRE-1920. Built in 1909, this was one of Boise's longest-running hotels. It closed in 2013 and has been remodeled as an apartment building. The building on the right was replaced with an extension of the hotel. That extension is now gone. Buildings behind the hotel (on the left) are now gone; that area today is a parking lot.

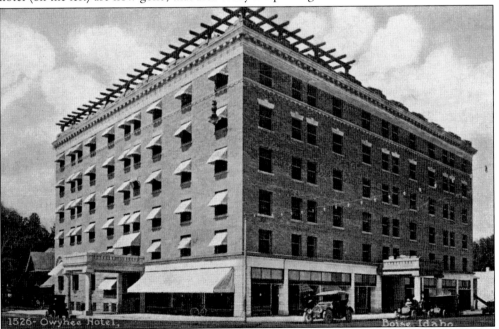

OWYHEE HOTEL, PRE-1910. Note the house on the south (left) side. In previous views, buildings are located there. This later became the site of the Bristol Hotel. The roof garden on the east side of the Owyhee Hotel is covered by wooden beams. These were removed many years ago. The building seems to be devoid of any signs.

33

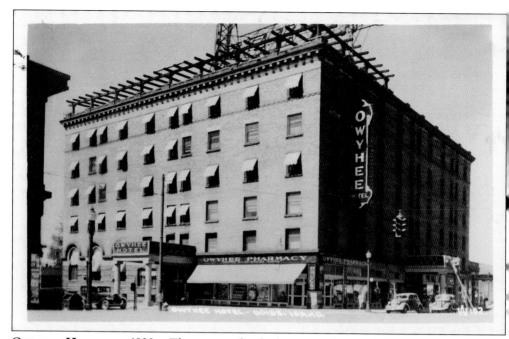

OWYHEE HOTEL, C. 1930S. The support for the large Owyhee Hotel sign is partially visible on the roof. Many signs are present in this photograph. The vertical sign on the corner of the hotel was recently re-created and installed on the building, which is now used for apartments.

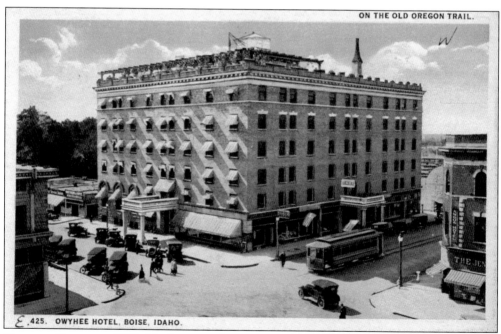

OWYHEE HOTEL, C. 1920. The house on the south (left) side has been replaced with a commercial building. Note the automobiles parked at angles. This manner of parking is no longer seen in downtown Boise. The sign at far right, beginning "The Jen," is believed to be for the Jenkins Furniture Company. Above that is the Angus Hotel sign.

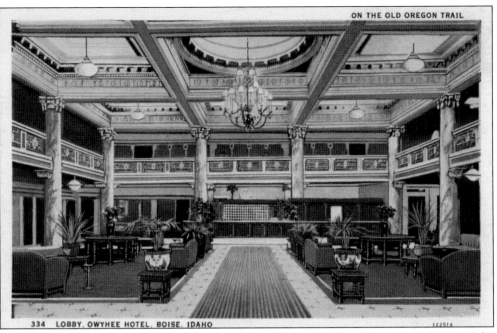

334 LOBBY, OWYHEE HOTEL, BOISE, IDAHO

OWYHEE HOTEL LOBBY, 1920s. The front desk was later moved to the north end, around the corner. This area was later used as a lobby. The building has been completely remodeled.

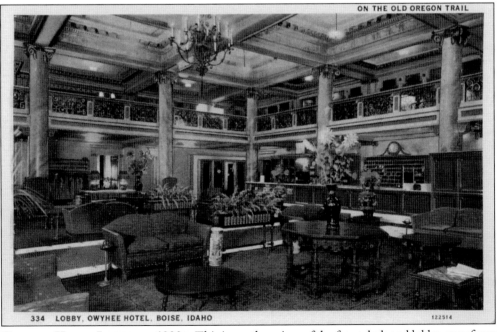

334 LOBBY, OWYHEE HOTEL, BOISE, IDAHO

OWYHEE HOTEL LOBBY, C. 1920s. This is another view of the front desk and lobby, seen from a different angle. The front desk was later moved around the corner on the left. The balcony remained the same throughout the hotel's life.

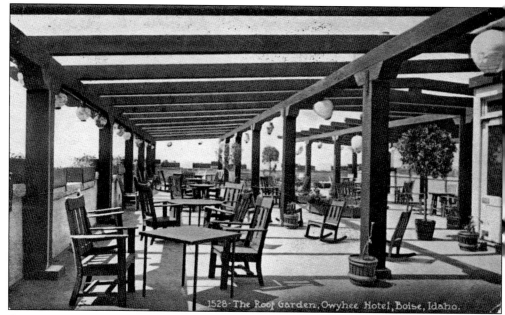

OWYHEE HOTEL ROOF GARDEN, C. 1910. A hanging garden supported by wooden beams existed on top of the Owyhee Hotel for several years. The beams can be seen on top of the building in many early hotel views. This card is postmarked 1911.

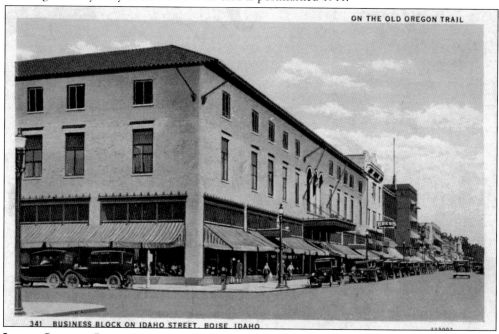

IDAHO STREET, LOOKING EAST FROM TENTH STREET, LATE 1920s. The C.C. Anderson Building, in the foreground, was built in 1926. It later became the Bon Marché and, finally, Macy's. It was one of the last major department stores in downtown Boise. The building is currently empty, awaiting development. The Kress five-and-dime store, east of the Anderson building, operated in Boise for many decades. Today, a nine-story office building occupies the location.

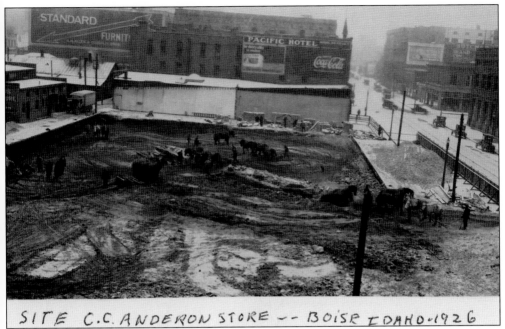

SITE C.C. ANDERON STORE -- BOISE IDAHO-1926

C.C. ANDERSON BUILDING UNDER CONSTRUCTION, 1926. This is not a postcard, but it is interesting to see the use of horses and wagons in the construction of the C.C. Anderson Building. Note the truck in the upper left.

IDAHO STREET, LOOKING EAST FROM ELEVENTH STREET, LATE 1920s. Idaho Street was the financial center of Idaho for many years, as most of the major state banks were located on it. Today, many are on Main Street and on side streets. Links Business College (right) later became part of ITT Technical Institutes.

IDAHO STREET, LOOKING WEST FROM EIGHTH STREET, LATE 1940S. Walgreens, seen here on the north side of the street (far right), left Boise in the early 1950s, only to return over 50 years later. Across the street is the Mode Building, constructed in 1909. It burned down in 1958 and was then rebuilt and restored. It was home of the Mode Clothing store for many years. Today, it is a multiuse office and retail center.

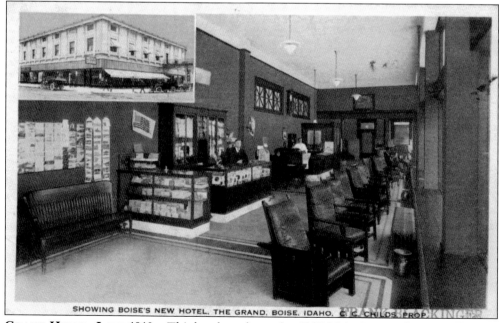

SHOWING BOISE'S NEW HOTEL, THE GRAND, BOISE, IDAHO. C. C. CHILDS PROP.

GRAND HOTEL, LATE 1910S. This hotel was located at 1025 Main Street. The upper floors of the building are now part of the Safari Inn. This card is postmarked 1918.

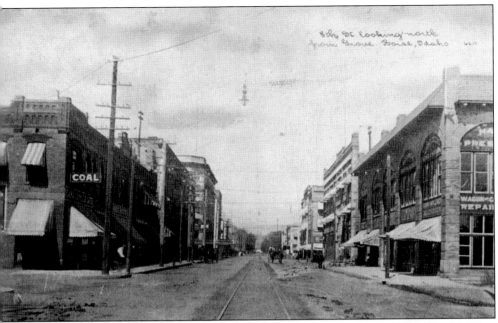

Handwritten at top right: 8th St looking north from Grove, Boise, Idaho

EIGHTH STREET, LOOKING NORTH FROM GROVE STREET, PRE-1915. The tallest building on the right is the Eastman Building, which burned down in January 1987. Across the street is Falk's department store. That location is now occupied by a multiuse parking garage and office building. Most of the buildings on this street no longer exist.

Street View of Boise, Idaho, from Overland Pharmacy Co.

Handwritten across lower portion: Why Hello art — Well I have got around at last to drop you a postal I am at Boise Idaho today and certainly do like the town

CORNER OF EIGHTH AND MAIN STREETS, C. 1909. The Eastman Building has yet to have its additional two stories added. Erected in 1899, the Odd Fellows Hall is next to the Eastman Building. It was also a victim of the urban renewal project of the 1970s. On this card, postmarked March 19, 1909, the image covers only the top half of the card; the rest of the card is reserved for messages.

39

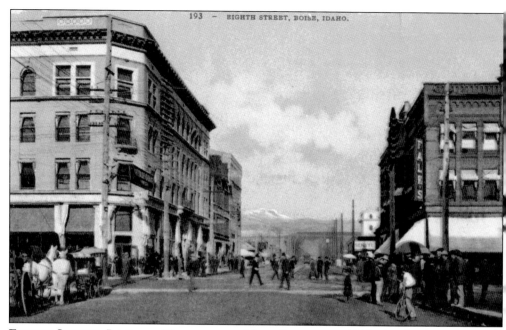

EIGHTH STREET, LOOKING NORTH FROM MAIN STREET, C. 1910. On the far right, in the distance, can be seen a small portion of the Federal Building. On the Eastman Building (center, left) is a sign for the Overland Hotel. Most of the buildings in this photograph are gone.

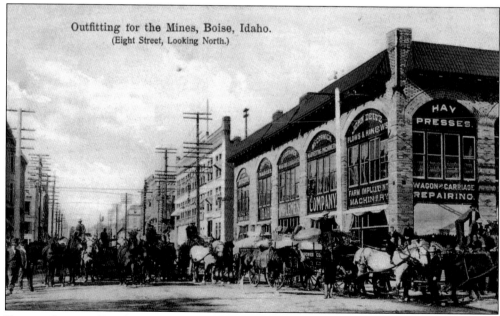

Outfitting for the Mines, Boise, Idaho.
(Eight Street, Looking North.)

EIGHTH STREET, LOOKING NORTH, PRE-1910. This caption reads "Outfitting for the Mines." This photograph was probably taken from Main Street. The majority of these buildings no longer exist. Note that only horses and wagons are present, no automobiles.

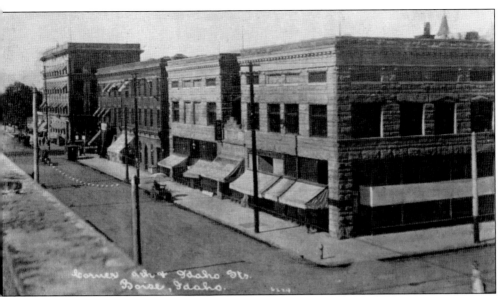

NINTH STREET, FROM IDAHO STREET, PRE-1910. The building on the right burned down in 1950. At the time, it was occupied by Montgomery Ward. In 1957, First Security Bank built a five-story office building on the site. In the center is the Sonna Building, and across the street is the Yates Building. It was torn down in the early 1970s. Today, the site is an open area next to One Capital Center. This photograph with a north-facing view must have been taken in the early morning or on a Sunday, as little traffic is present.

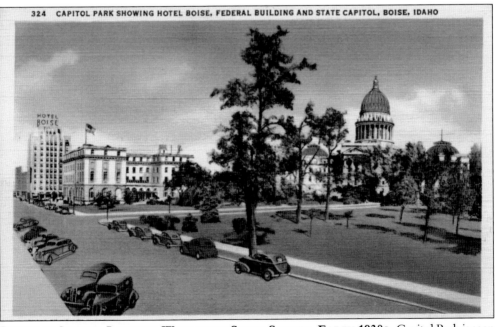

324 CAPITOL PARK SHOWING HOTEL BOISE, FEDERAL BUILDING AND STATE CAPITOL, BOISE, IDAHO

BANNOCK STREET, LOOKING WEST FROM SIXTH STREET, EARLY 1930s. Capitol Park is seen at right. Note the angled parking on the left, which is no longer done on streets in downtown Boise. It is interesting to note that the dome of the state capitol is painted gold (in the color-tinted view). This appears on many postcards of the capitol, but the dome was never painted gold.

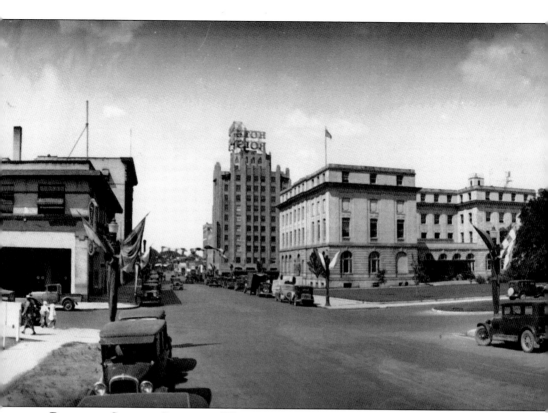

BANNOCK STREET, LOOKING WEST FROM CAPITOL BOULEVARD, C. 1930S. This great panoramic view looking west includes cars common in that era. Most of the buildings in this

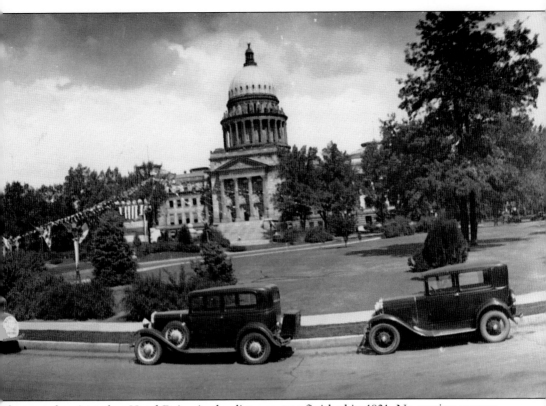

photograph exist today. Hotel Boise, in the distance, was finished in 1931. No caption appears on this card.

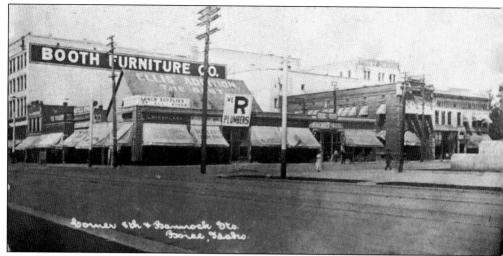

CORNER OF EIGHTH AND BANNOCK STREETS, PRE-1929. The area occupied by the Ellis Addition became the site for the Hotel Boise. The location of the two buildings north of it is now a parking lot. The Booth Furniture sign is seen on the Carol Building.

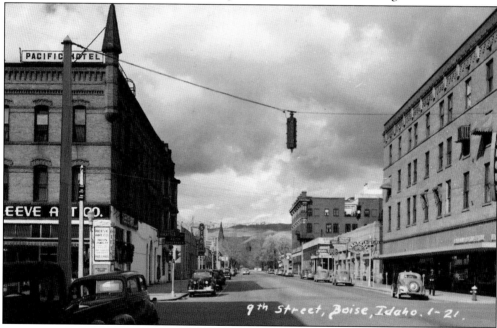

NINTH STREET, LOOKING NORTH FROM IDAHO STREET, C. LATE 1940s. The Pacific Hotel building on the right no longer exists, and the location is occupied by a nine-story office building. In the distance on the left is the sign for the Stage Depot; for several years, it was the Greyhound station, which moved a few blocks to the west in the early 1960s. Farther down the block is the Trailways bus depot, which opened at that location in November 1948. It moved across the Boise River to South Eighth Street in 1972. The Elks Building is on the far right in the distance, and the McCarty Building is on the near far right. Sen. William Borah's legal offices were in the McCarty Building for several years. The "Drugs" sign partially seen on the right edge of the photograph is for Ballou-Latimer Drug Store, which operated in Boise for over 100 years.

EIGHTH STREET, FROM MAIN STREET, MID-1940s. Partially visible at left is the First National Bank Building, constructed in 1902 and torn down in 1972. On the left toward the north are the Eastman Building, Odd Fellows Hall, the Boise National Bank Building, the Mode, and the Hotel Boise. On the right are the Idaho Hardware Building, the Falk's Building, Fidelity Building, and the Idaho Building. Only a few of these exist today.

EIGHTH STREET, LOOKING NORTH, MID-1940s. On the left is the Hotel Boise, with the KIDO Radio sign. KIDO operated from the Hotel Boise for several years. The station occupied the mezzanine and ninth floor. The Owl Drug sign is on the Idaho Building at right; north of it is the Federal Building. The buildings seen just north of the Hotel Boise no longer exist, and their location is now a parking lot. This photograph was taken from just south of Bannock Street.

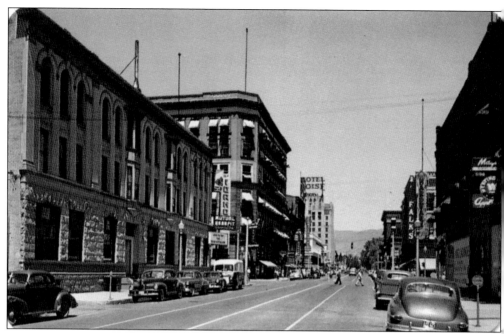

EIGHTH STREET, FROM SOUTH OF MAIN STREET, LATE 1940s. This is a chrome color card. On the top of the Hotel Boise is its lighted large sign. This sign was used by pilots at night as a beacon to locate downtown Boise, until it was torn down for the building's remodeling. The Idaho State Historical Society has the sign in storage.

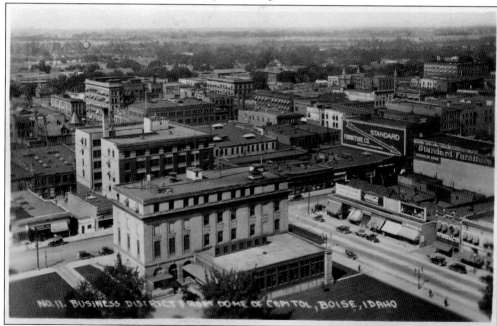

BUSINESS DISTRICT, FROM CAPITOL DOME, MID-1920s. The buildings at lower right, where the Coca-Cola sign is seen, were town down for the Hotel Boise. The area in the distance is mostly open fields in this image, but that is no longer the case today. The Federal Building in the foreground has yet to have its extension added.

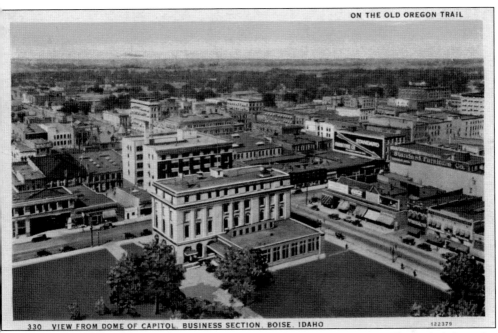

330 VIEW FROM DOME OF CAPITOL, BUSINESS SECTION, BOISE, IDAHO 122379

BUSINESS DISTRICT, FROM CAPITOL DOME, MID-1920s. This image offers a slightly wider view than that in the previous card. The Empire Building is at upper far right. Many of the buildings seen here no longer exist. This is a color-tinted card.

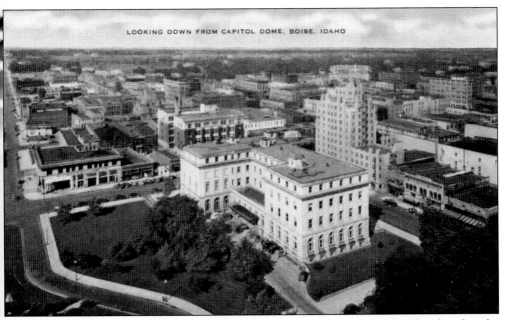

LOOKING DOWN FROM CAPITOL DOME, BOISE, IDAHO

VIEW FROM CAPITOL DOME, MID-1930s. The Hotel Boise has been completed, as has the extension to the Federal Building. All of the buildings north of the Hotel Boise are now gone, and their former sites are today parking lots.

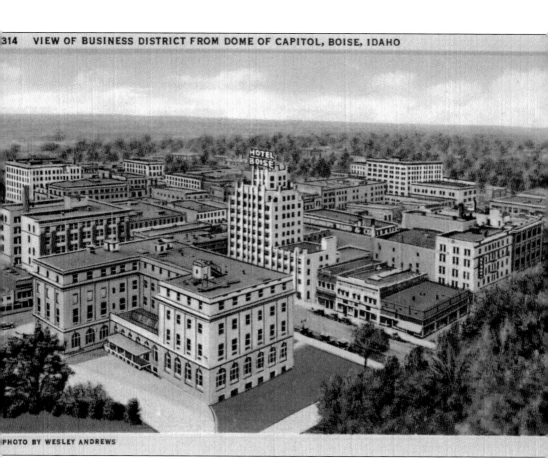

PHOTO BY WESLEY ANDREWS

BUSINESS DISTRICT FROM CAPITOL DOME, 1930s. This color-tinted card is a little sharper than the previous ones. On the far right is the Pinney Theater, built in 1908. Its sign is on the corner of the building. The structure was torn down in the 1970s, and the site is now a parking lot.

Four

BOISE PARKS

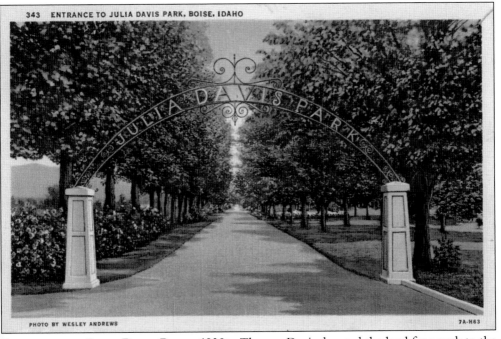

343 ENTRANCE TO JULIA DAVIS PARK, BOISE, IDAHO

PHOTO BY WESLEY ANDREWS 7A-H63

ENTRANCE TO JULIA DAVIS PARK, 1930S. Thomas Davis donated the land for a park to the City of Boise in 1907. He came to the Boise area in 1862 and later built a cabin at the site and started an apple orchard. Julia Davis Park, named for Davis's wife, is Boise's premier park and today contains the Idaho State Historical Museum, Boise Art Museum, Idaho Black History Museum, Gene Harris Band Shell, and Zoo Boise. The entrance gate today looks very similar to this view.

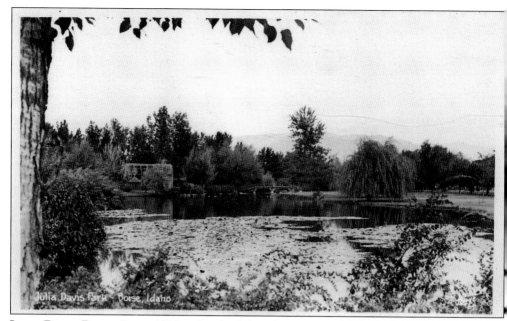

JULIA DAVIS PARK, LATE 1930s. On the left is the Boise Zoo, within Julia Davis Park. The zoo has since expanded to include land on the right. Boise's zoo got its start when an escaped circus monkey was found in the desert near Mountain Home. A cage was built for it at the park, and so began Zoo Boise.

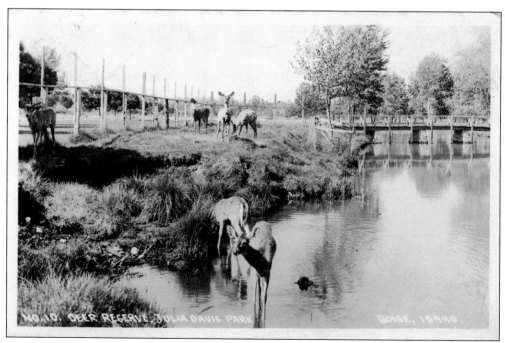

JULIA DAVIS PARK DEER RESERVE, 1930s. The deer reserve was a park within the zoo. The reserve no longer exists, and the land is now used for other zoo exhibits. Originally, the zoo had many animals from the Northwest. Today, its offerings are more international in scope.

50

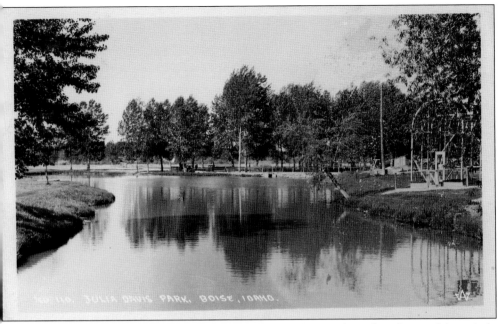

JULIA DAVIS PARK, 1930s. The zoo is on the right of the pond. Today, the pond is entirely within the zoo's property. Note the automobile near the center. Today, paddleboats can be rented for use on the pond.

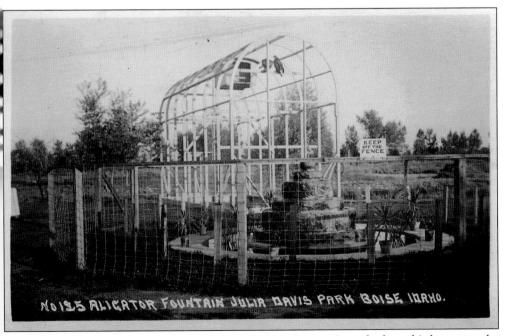

ALLIGATOR FOUNTAIN, JULIA DAVIS PARK, 1930s. At one time, the large birdcage was the main attraction of the zoo. In front of it was a fountain and pond that housed alligators. None of this exists today.

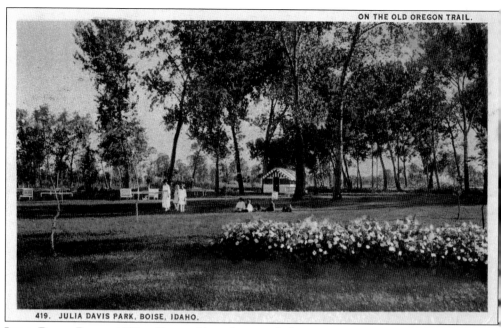

419. JULIA DAVIS PARK, BOISE, IDAHO.

JULIA DAVIS PARK, 1920s. Pictured here is a wooded open area with a small building in the background. Before the land was donated for a park, it was an orchard. The rose garden in front is still maintained today. This card is postmarked 1925.

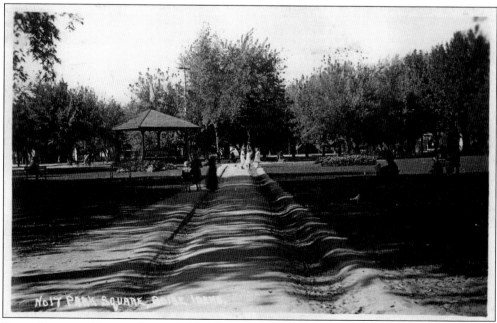

PARK SQUARE, 1920s. This was near the capitol. The park was removed with the expansion of the new state capitol. This card is postmarked 1925.

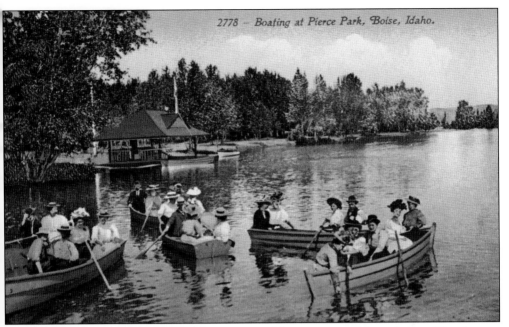

PIERCE PARK, C. 1910. Pierce Park was west of downtown, off State Street. The site was selected because it was on the Boise Interurban route to Caldwell. The location is now home to the Plantation Golf Course. It was created in 1908 by local developer W.E. Pierce.

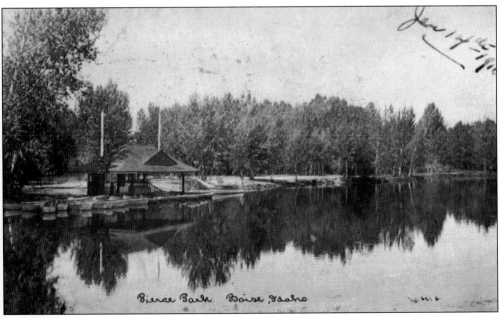

PIERCE PARK, 1910s. Lake Elmore is shown here. The park had a very popular dance pavilion. Rowboats were available to rent on the lake. Today, the Plantation Golf Course occupies the site. This card is postmarked 1910. (Courtesy Albert Hale collection.)

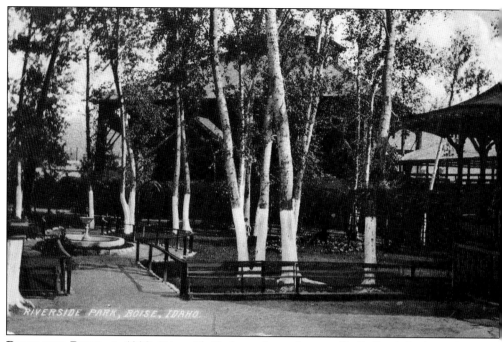

RIVERSIDE PARK, C. 1908. Riverside Park was located west of Julia Davis Park on the Boise River, across Capitol Boulevard. Later, the area was used for warehouses; today, it contains office buildings.

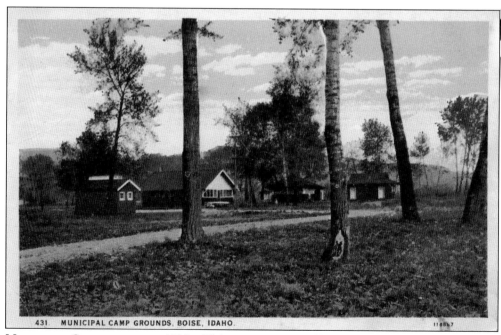

MUNICIPAL CAMPGROUNDS, 1920s. This area was originally set up as a baseball field in 1910. It became Boise Tourist Park Campground in 1918. In 1927, the city bought the property and renamed it Municipal Park. It is on the north side of the Boise River, east of downtown, and is still in use today.

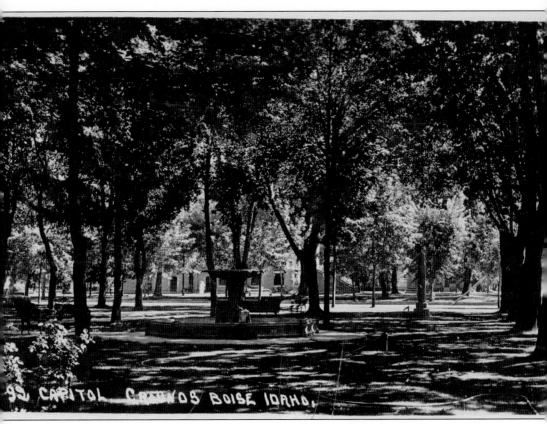

PARK AREA NEAR CAPITOL BUILDING, C. 1920. A fountain stands in the center of this photograph. The area was later used for the expansion of the state capitol. The old capitol building can be seen in the background. This card is postmarked 1920.

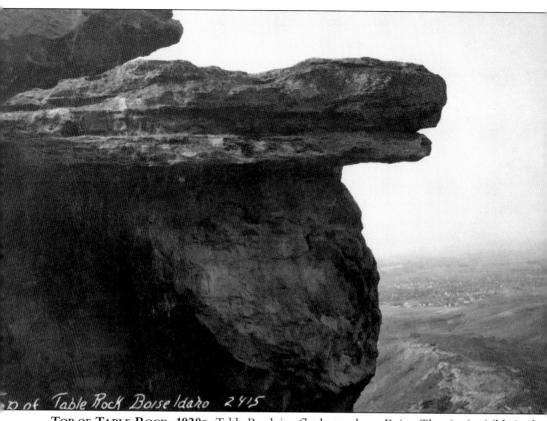

TOP OF TABLE ROCK, 1920s. Table Rock is a flat butte above Boise. The city is visible in the valley on the right. Sandstone from Table Rock has been used for many of Boise's buildings.

Five

AERIAL VIEWS OF BOISE

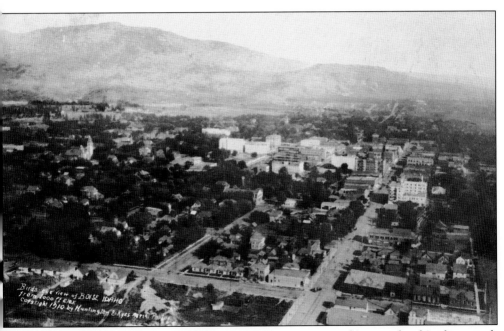

BIRD'S-EYE VIEW OF BOISE, C. 1910. A camera was put on a kite to take this photograph from 1,000 feet. The view is looking east over downtown. Many of the houses in the foreground have been replaced by office buildings. It is hard to see, but the state capitol's dome is under construction north of the Federal Building.

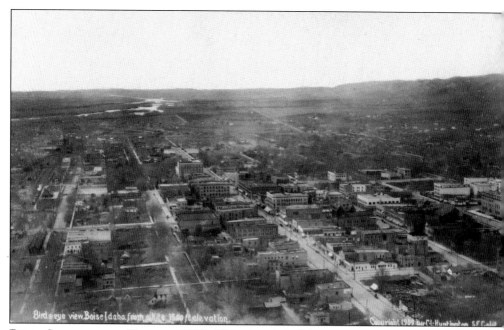

BOISE SEEN FROM A KITE, C. 1909. This view is looking west over downtown Boise from 1,500 feet. The Eastman Building can be seen in the center. The Owyhee Hotel is toward the right. It is interesting to note that downtown ends at Sixteenth Street and that from there to the west is open fields. The Boise River is seen in the distance.

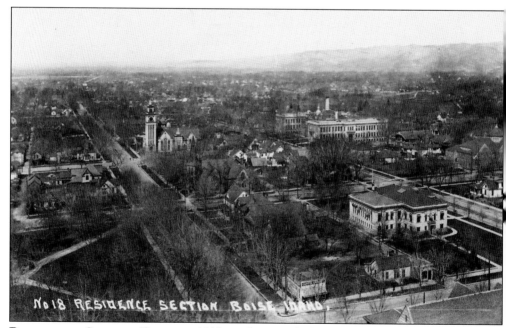

RESIDENTIAL SECTION, BOISE, C. 1910. In this view looking west from the capitol dome, the library and Boise High School are shown. The school's new center section has yet to be added. The park below the dome was eventually the site of the west wing of the capitol. The Boise River can be seen in the upper right corner.

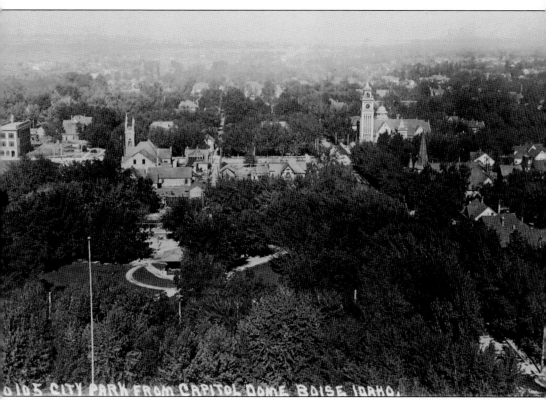

CITY PARK FROM CAPITOL DOME, C. 1910. At far left is the Elks Building. The three-story building across from it no longer exists. The park was later replaced with the west wing of the capitol. There have always been many trees in the city, leading to Boise being known as the "City of Trees."

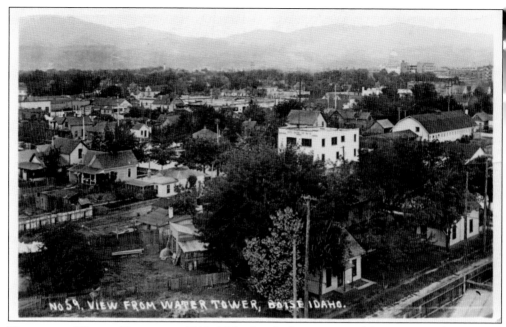

VIEW FROM WATER TOWER, C. 1910. This view looks east toward downtown, which can be seen in the distant upper right. The state capitol and Empire Building are easily seen. Most of the houses seen here are now gone.

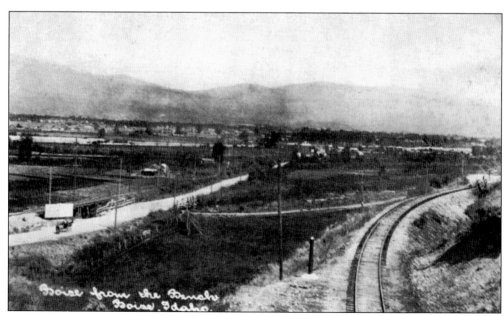

BOISE FROM THE BENCH, C. 1910. The view in this postcard, postmarked 1911, looks east from the bench toward downtown. The rail tracks on the rim are for the Boise Interurban. The street on the left is probably Fairview Avenue, a major multilane thoroughfare today.

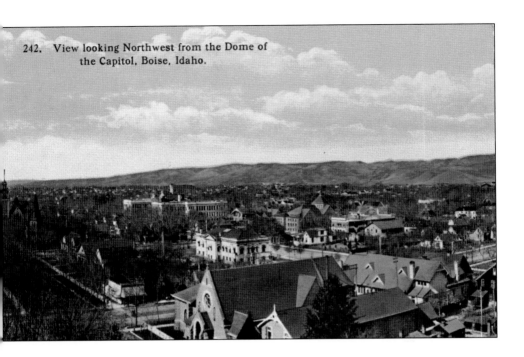

242. View looking Northwest from the Dome of
the Capitol, Boise, Idaho.

VIEW LOOKING NORTHWEST FROM CAPITOL DOME, PRE-1920. The library and Boise High School are seen in the distance in the above card. The high school still has its original center redbrick building. The below card features the smokestack for a powerhouse that no longer exists. The site is now occupied by a state office building. Boise's Front Range has snow along the mountains. These two cards are from a panoramic photograph, here split in half.

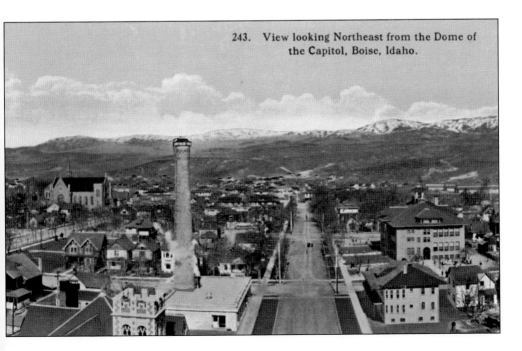

243. View looking Northeast from the Dome of
the Capitol, Boise, Idaho.

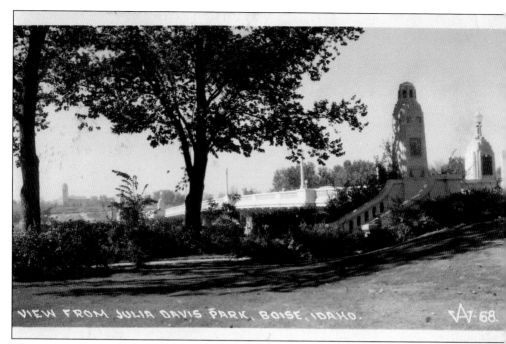

MEMORIAL BRIDGE, LATE 1930s. This bridge was opened to traffic in 1931, completing Capitol Boulevard. Before its construction, a small ferry was used to cross the river. The train depot can be seen on the far right. This photograph was taken in Julia Davis Park. The card is postmarked 1942.

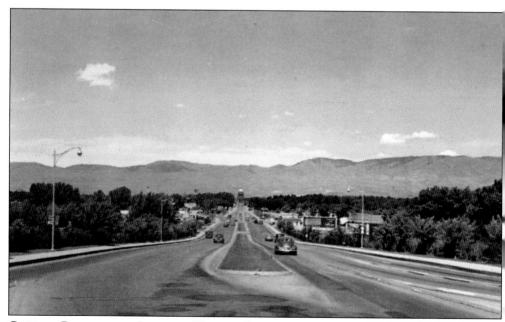

CAPITOL BOULEVARD, LOOKING NORTH, LATE 1930s–EARLY 1940s. The state capitol is visible at the end of Capitol Boulevard. Hotel Boise is to the left, with its large red sign on top. All of the buildings on both the left and right sides of Capitol Boulevard going down the hill are gone today.

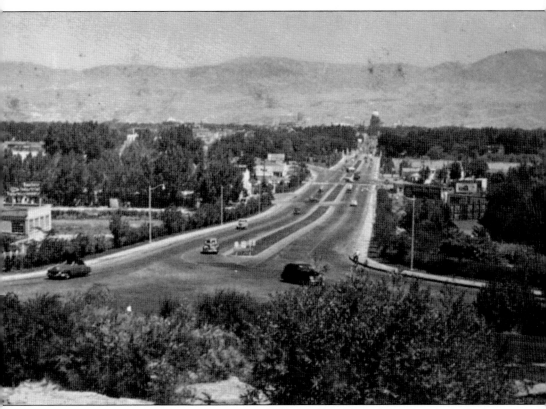

CAPITOL BOULEVARD, LOOKING NORTH, LATE 1930s–EARLY 1940s. This view looks farther to the west than that in the previous postcard. The open field on the right side about center is where Boise State University is today. Directional signs now appear on the grassy divider.

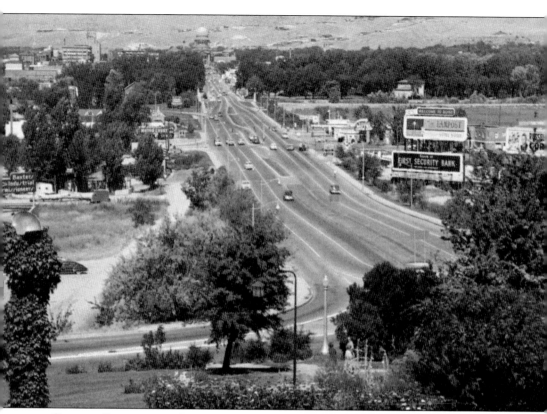

CAPITOL BOULEVARD, LOOKING NORTHEAST, EARLY 1950s. The band shell at Julia Davis Park is seen in distance. The open field in front of it is now the location of Boise State University. Billboards are seen on the right. On the left in the distance is Hotel Boise, with the Eastman Building in front of it. This view, from the train depot, looks completely different today.

Six

FORT BOISE

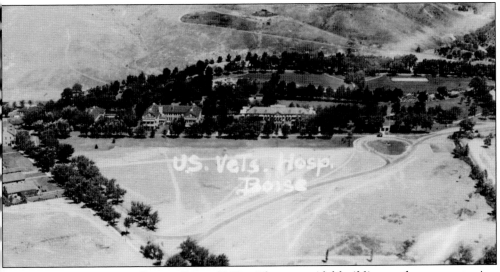

AERIAL VIEW OF FORT BOISE, LATE 1930s. The pyramidal building at the top center is a water reservoir, still there today. The Main Hospital is in the upper center, and the open ground is now a city park. Fort Boise was the beginning of Boise, but it was not the first Fort Boise. The Hudson's Bay Company opened the first Fort Boise at the confluence of the Boise and Snake Rivers in 1834. A second location was selected in 1838, and it is believed today that this site is now underwater due to the shifting of the Snake River. The fort was closed in 1854 amid Indian attacks. The city of Parma has a replica of the fort, which is well worth visiting. Gold was discovered in the Boise Basin in 1862; in 1863, it was decided that a fort was needed for the protection of the miners. The location selected was where the road to Idaho City met the Oregon Trail. It was established on July 4, 1863, by Maj. Pinkney Lugenbeel. Over the years, it was also known as Boise Barracks and Camp Boise. In 1912, the Army left the site, and the Idaho National Guard took over until 1919, when it was converted to hospital use for World War I veterans. In 1938, the Veterans Administration took over. In 1950, a portion of the fort was given to the City of Boise for the creation of a park, which contains the original buildings, the oldest in the city.

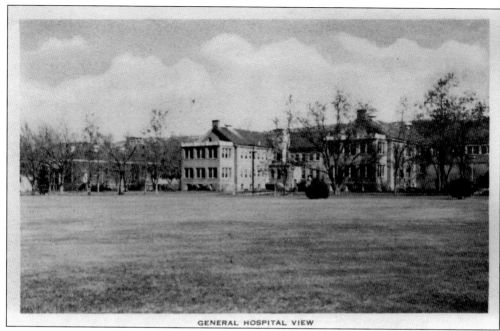

GENERAL HOSPITAL VIEW

GENERAL HOSPITAL, LATE 1940s. The General Hospital looks pretty much the same today.

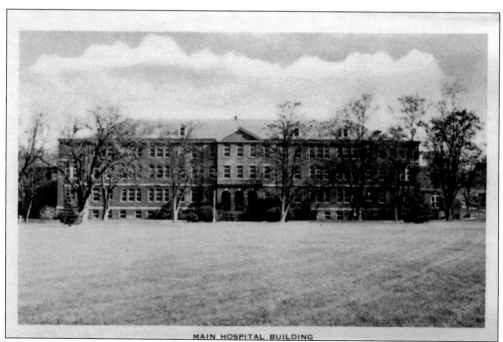

MAIN HOSPITAL BUILDING

MAIN HOSPITAL BUILDING, LATE 1940s. The main hospital building still functions as the same facility today.

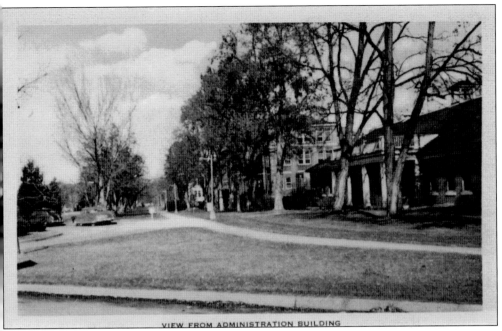

ADMINISTRATION BUILDING, 1940s. The Administration Building is also the same today.

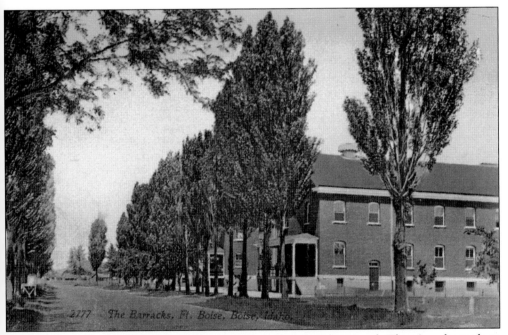

THE BARRACKS, FORT BOISE, 1920s. This is a color-tinted postcard. The view shown here looks pretty much the same today, but the road is now paved.

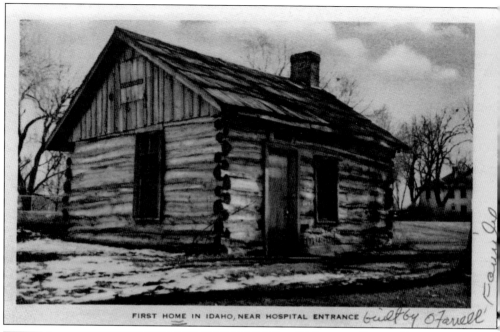

FIRST HOME IN IDAHO, NEAR HOSPITAL ENTRANCE *built by O'Farrell*

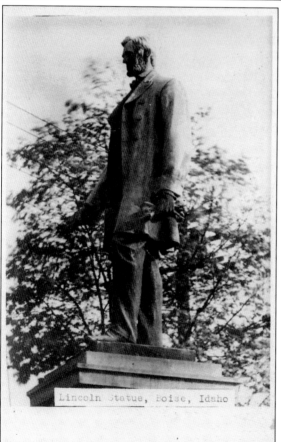

Lincoln Statue, Boise, Idaho

O'FARREL CABIN, LATE 1940S. This is considered to be the oldest building in Boise. It is maintained by the city and is still located on the grounds of Fort Boise. Built in 1863 by John O'Farrell, it is also considered to be the site of the first Catholic worship in Boise. The structure was originally located across the street and was restored in 2002. It is now in the National Register of Historic Places. The City of Boise conducts tours of the cabin.

LINCOLN STATUE, 1930S. Boise has few statues. This one of Pres. Abraham Lincoln was initially at the Idaho Soldiers Home, then moved to the State Veterans Home, which was off State Street. Today, the site of the State Veterans Home is Veteran State Park. The statue now stands about a block south of the capitol.

Seven

BUILDINGS

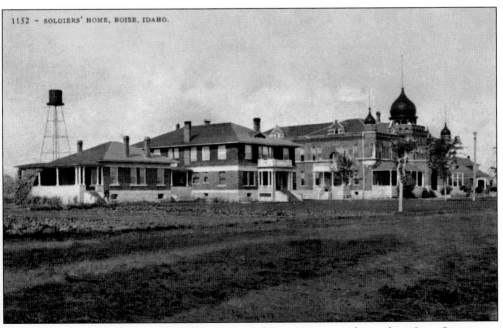

1152 - SOLDIERS' HOME, BOISE, IDAHO.

BOISE SOLDIERS HOME, C. 1907. The Boise Soldiers Home was located on State Street near Thirty-sixth Street. It is now the site of Veterans State Park, which is located on Boise Cascade Lake and the Boise River, a popular fishing area in the city limits.

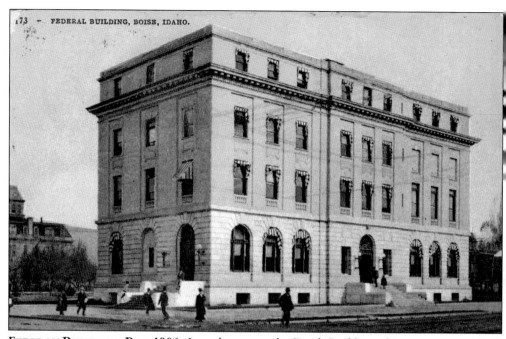

FEDERAL BUILDING, PRE-1906. Later known as the Borah Building, this structure was built in 1902 and served as a post office and the Federal Building. It is located on the north side of Bannock Street at the corner of Eighth Street. Behind it is the Public Service Building. This card is postmarked 1916.

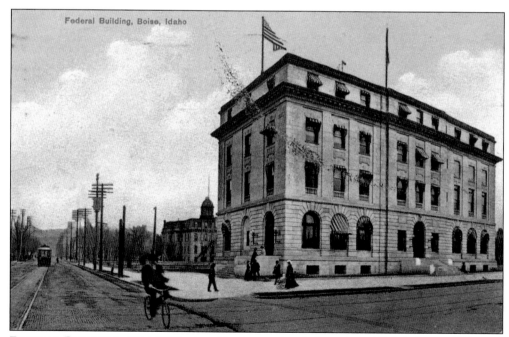

Federal Building, Boise, Idaho

FEDERAL BUILDING, PRE-1906. A trolley is seen headed north on Eighth Street. This card is postmarked 1910. Note that no cars are seen in this view, and that power poles are now prominent along the street.

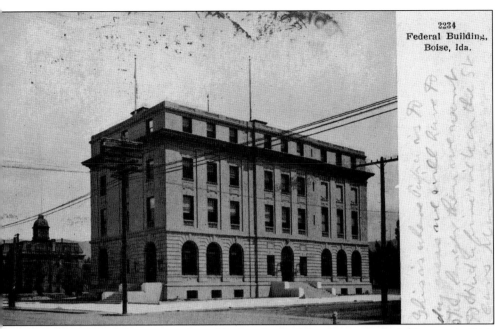

FEDERAL BUILDING, PRE-1906. The Public Service Building is seen in the background of this card, postmarked 1909. This early card has a space on the front right on which to write messages. Note that no vehicles or people are seen in this view.

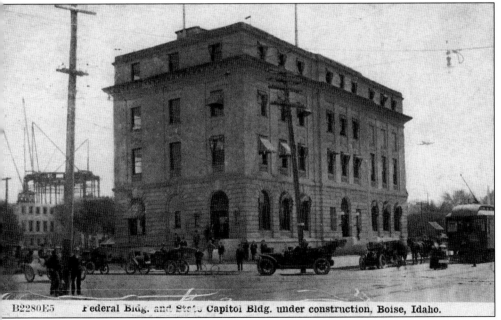

FEDERAL BUILDING, C. 1906. The Public Service Building is gone, and the new state capitol is under construction. Automobiles now dominate the streets. At right is an interurban trolley. The card is postmarked 1914.

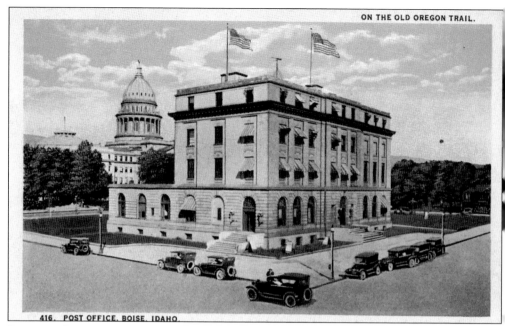

FEDERAL BUILDING, POST-1917. The caption at top reads "On the Old Oregon Trail." The new capitol building is completed, and the extension to the Federal Building has been made. Note the addition of streetlights.

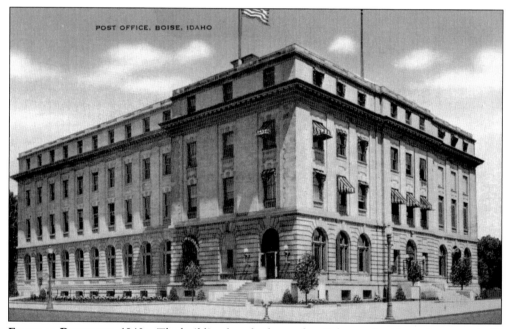

FEDERAL BUILDING, 1940s. The building here looks much as it does today. Extensions were built in 1917 and 1929. Today, the building is under the control of the state government. It was used as a federal office building for years, as well as the main post office. The current Federal Building is on Front Street, next to Fort Boise. The main post office is now on Thirteenth Street, just north of the river. The post office in this building is today known as the Borah Post Office.

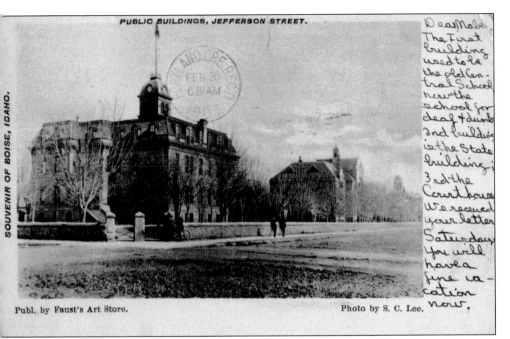

Publ. by Faust's Art Store. Photo by S. C. Lee.

PUBLIC SERVICE BUILDINGS, PRE-1906. To the right is the old state capitol. At far right is the old Ada County Courthouse. This structure was torn down to make room for the new capitol.

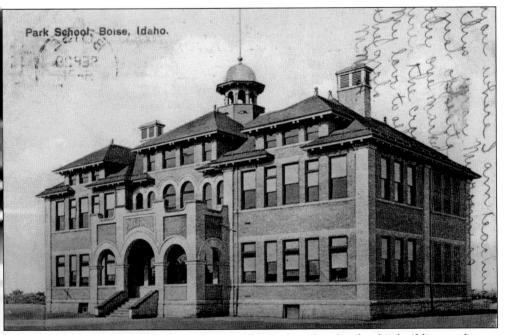

PARK SCHOOL, 1905–1906. One of many of Boise's early schools, this building no longer exists. This school stood at the intersection of Fairview Avenue and Main Street. The card is postmarked 1908. Like many early US postcards, this one was printed in Germany.

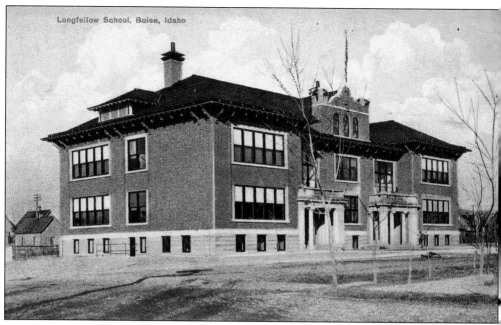

LONGFELLOW SCHOOL, C. 1910. Still in use today, this is one of Boise's oldest existing schools. It is located at 1511 North Ninth Street. Note the very small houses to the left behind the school.

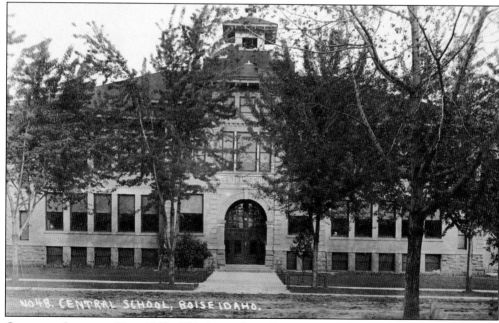

CENTRAL SCHOOL, PRE-1910. This is another of Boise's early schools that no longer exists. Built in 1882, it was used for high school students until Boise High was built. Note the unpaved road seen in the foreground of this postcard, postmarked 1917.

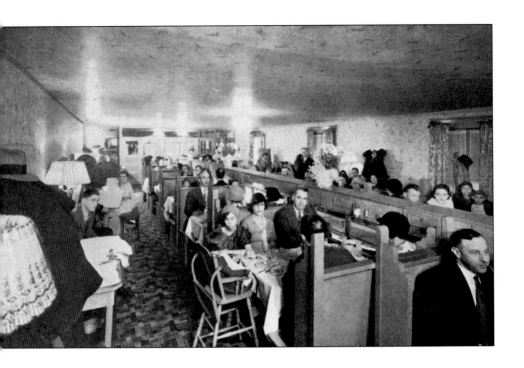

THE NEW MECHANAFE, 1930s. Locate at 211 North Eighth Street, this "100% Waiterless Restaurant" opened in 1929. A mechanical belt carrying food kept moving past patrons. For 25¢, customers got all they could eat. On the back of this postcard is written, "It's the showplace of Idaho." The restaurant closed in the 1940s.

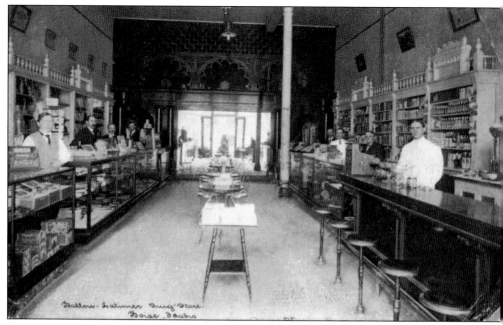

BALLOU LATIMER DRUG, PRE-1910. Ballou Latimer Drug operated in Boise for over 100 years. In later years, it also specialized in photographic equipment and Hallmark cards. It was located in the McCarty Building, at the northeast corner of Ninth and Idaho Streets. Today, this location is occupied by a deli.

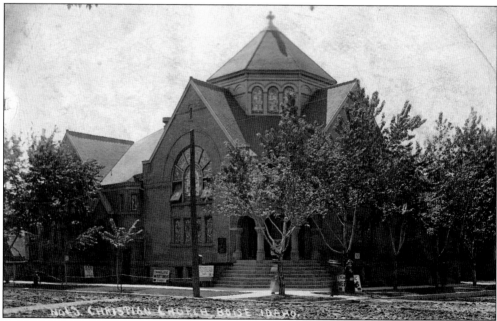

CHRISTIAN CHURCH, PRE-1920. Many of Boise's early churches were located in what is known as the North End. The streets of downtown Boise are oriented to the southeast and northwest to follow the original Oregon Trail and the Boise River. When the area of north downtown was developed for residences, it was decided to orient the streets to the north and south, creating some interesting intersections. Note the unpaved road.

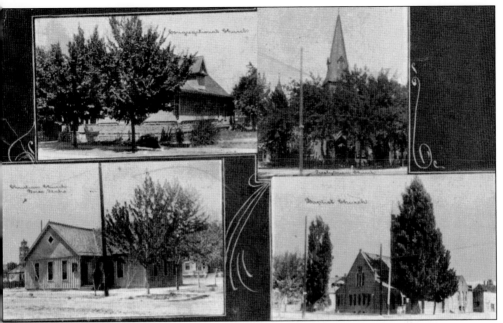

BOISE CHURCHES, PRE-1910. This crudely made card with handwritten captions shows four early Boise churches. They are, clockwise from top left, the following: Congregational church, Presbyterian church, Baptist church, and Christian church. The Baptist church was located at Tenth and Jefferson Streets.

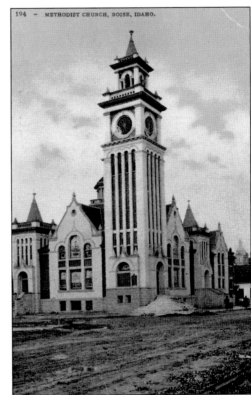

METHODIST CHURCH, C. 1910. Boise's First Methodist Church was built in 1872. A larger church was constructed in 1902 at Tenth and State Streets. It is believed that this postcard shows that church. In 1960, a new Methodist church, known as the Cathedral of the Rockies, was opened at Eleventh and Hays Streets.

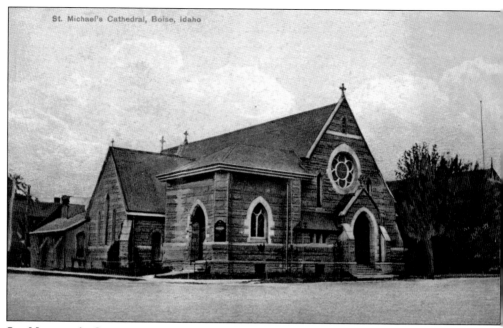

St. Michael's Cathedral, Boise, Idaho

ST. MICHAEL'S CATHEDRAL, C. 1920S. This was the Episcopal church, built around 1902 in the English Gothic style. The sandstone was from Table Rock. The church building is still in use today at 52 North Eighth Street. One of Boise's earliest radio stations operated from here from 1923 to 1925. The station, whose call letters were KFDD, operated only on Sundays. It was later reported that the transmitter was stolen and the station left the air.

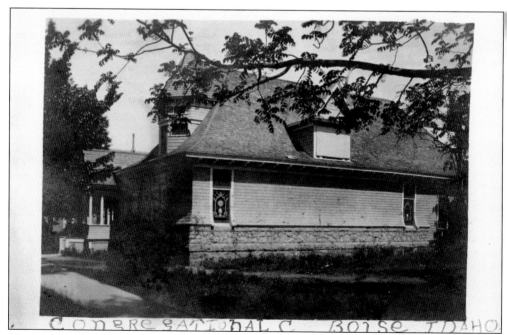

CONGREGATIONAL CHURCH, PRE-1910. This church is also seen on page 77. Note the handwritten caption at the bottom. This card is postmarked 1908.

GREETINGS FROM BOISE, IDAHO, C. 1910.
This composite card has photographs of the
Carnegie library, St. Michael's Cathedral, and
St. Teresa's Academy (misspelled St. Peresas
Academy). St. Michael's and the library still
exist today. Note the addition of the pictures of
little girls.

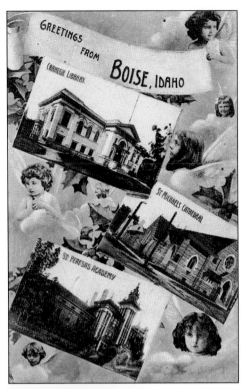

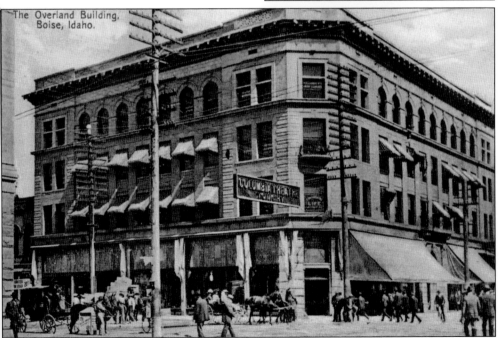

OVERLAND BUILDING, C. 1910. Built in 1905, this structure was the original site of the
Overland Hotel. The original building had just four floors. The sign hanging over the street
is for the Columbia Theatre. Only wagons and horses are seen, no automobiles. The first cars
came to Boise in 1906.

OVERLAND BUILDING AND MAIN STREET, PRE-1906. Interurban tracks can be seen in the road. Only wagons—no cars—are seen here. None of the buildings pictured in the photograph exist today.

EASTMAN BUILDING, PRE-1920. The Overland Building was renamed the Eastman Building in 1927. Additional floors were constructed in 1910. The building was home to many medical offices for years in downtown Boise. Plans were in place for the structure's remodeling, but it burned down in the late 1980s.

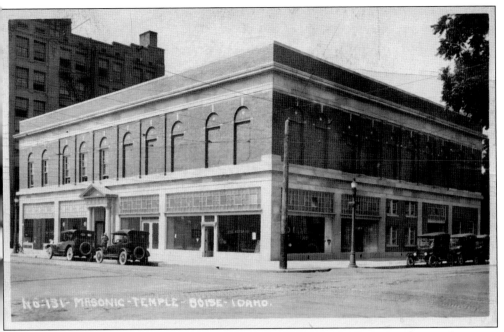

MASONIC TEMPLE, C. 1920S. Located at the northwest corner of Tenth and Bannock Streets, this building still exists today. The sign in the car at right reads "192? Stanley." The building was erected in 1906. The corner location has been occupied by a restaurant for several years.

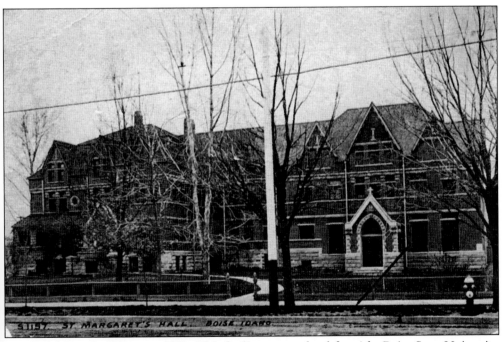

ST. MARGARET'S HALL, C. 1910. This facility was a school for girls. Boise State University was founded there in 1932. St. Margaret's, located at 100 West Idaho Street, was built in 1892 by the Episcopal Church. The card is postmarked 1915.

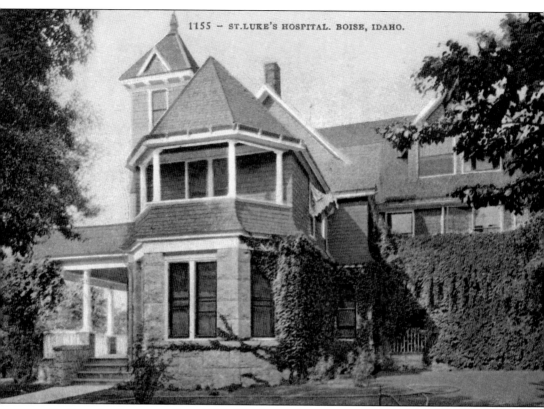

1155 – ST.LUKE'S HOSPITAL. BOISE, IDAHO.

ST. LUKE'S HOSPITAL, PRE–1920. This hospital was founded by the Episcopal Church in 1902. Today, it is owned by St. Luke's Health. St. Luke's maintains hospitals in Meridian, Jerome, Ketchum/Sun Valley, McCall, and at several satellite locations. Today, a nine-story tower is near this original location and several extension buildings. In 1927, work began on a north annex, which the author's grandfather helped build. (Courtesy Albert Hale collection.)

Eight

Boise High School

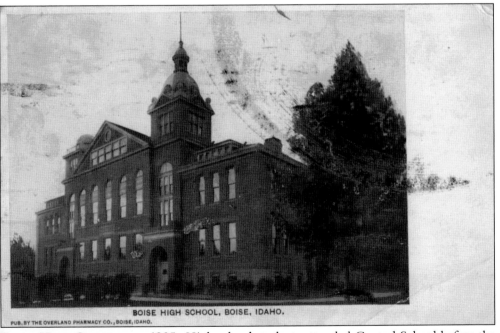

BOISE HIGH SCHOOL, BOISE, IDAHO.

PUB. BY THE OVERLAND PHARMACY CO., BOISE, IDAHO.

BOISE HIGH SCHOOL, C. 1905. High school students attended Central School before the building of Boise High School. The original redbrick building was erected in 1902. In 1908, the east wing was constructed. The west wing was added in 1912. The redbrick building was torn down in 1921. KFAU, Boise's first radio station, operated from Boise High School from 1922 to 1928. (See Art Gregory's *KIDO: Boise's First Radio Station*, published by Arcadia.) Boise High School has expanded over the years and today includes many additional structures. The original building was later replaced. Only a few years after being built, it was found to be inadequate to serve the high school population.

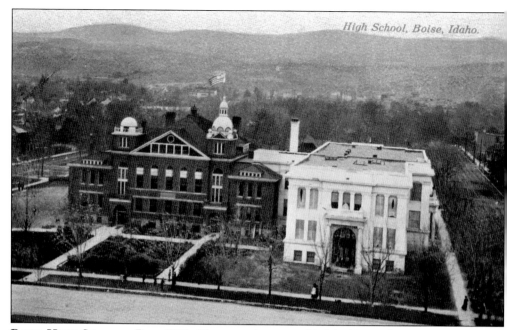

BOISE HIGH SCHOOL, PRE-1910. The east wing was added in 1908. The Boise Front Range can be seen in the background.

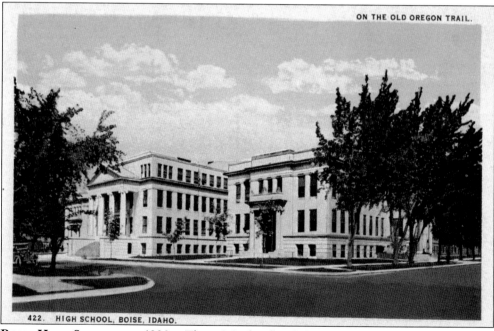

BOISE HIGH SCHOOL, C. 1920s. The original redbrick building has been replaced, and the west wing has been added. Boise's first radio station, KFAU, started at Boise High School in 1922. The city found operation of the station to be too expensive and sold it in 1928. The station became KIDO.

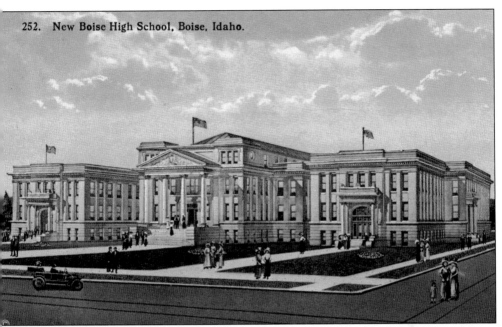

252. New Boise High School, Boise, Idaho.

BOISE HIGH SCHOOL, 1920s. This postcard offers a more direct view of the school, with the front of the west wing more visible. Note the car in front and interurban tracks in the road. The people are dressed in clothing typical of the period.

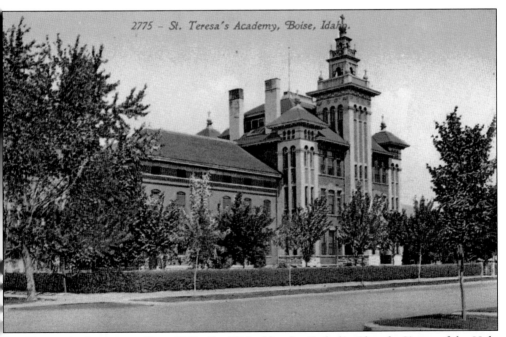

2775 – St. Teresa's Academy, Boise, Idaho.

ST. TERESA'S ACADEMY, PRE-1910. Established by the Catholic Church, Sisters of the Holy Cross opened in 1890 for young girls. The first real high school in Boise, it was located at 312 Jefferson Street. The facility closed in 1964, replaced by Bishop Kelly High School, which is located west of downtown on Franklin Road.

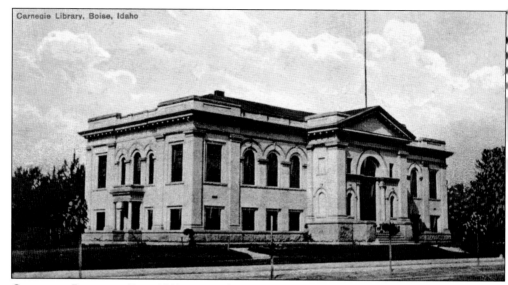

Carnegie Library, Boise, Idaho

CARNEGIE LIBRARY, PRE–1910. Located at 815 Washington Street, the library was completed in 1905, built with money donated by Andrew Carnegie and with local contributions. Land donated by the Boise School District made the library possible. The first Boise Public Library was located in the old city hall. In 1973, Boise bought the old Salt Lake City Hardware building on Capitol Boulevard just north of the Boise River. That location is the site of the library today. There has been discussion of building a new library. Today, the former Carnegie library is used as a private office building.

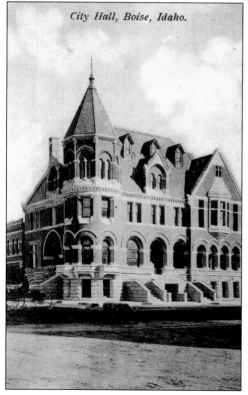

City Hall, Boise, Idaho.

CITY HALL, PRE-1906. This structure was built in 1893 in the Rhenish Romanesque style. It was torn down in mid-1953 and replaced by a building occupied for several years by Payless Drug. This was later torn down and replaced by a two-story parking garage and retail office building. Note that no automobiles are seen, just a carriage.

CITY HALL, PRE-1906. This postcard offers the same view as the previous postcard, but this card was colorized, emphasizing the building's red bricks. This card is postmarked 1909.

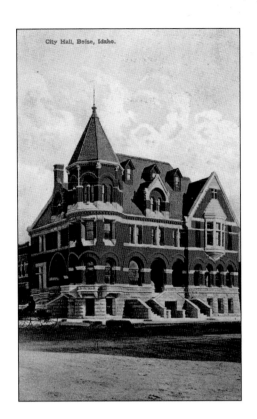

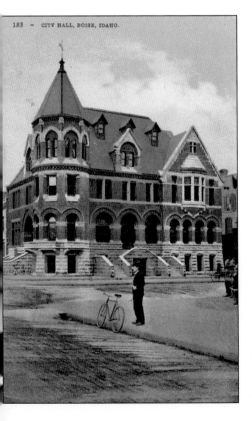

CITY HALL, PRE-1906. The man at center stands with an early bicycle, and a man at right appears to be wearing a type of helmet. Another bike leans against city hall. Note the style of rain gutter near the man with the bicycle. The street is not paved.

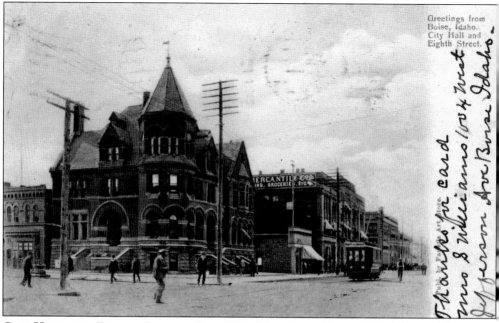

CITY HALL AND EIGHTH STREET, PRE-1906. Note the trolley on Eighth Street. The streets are devoid of automobiles. Just south of City Hall is a small building, then Falk's Department Store. Falk's had a "metal false front" on it to make it look more modern. All of the buildings in this view are gone today.

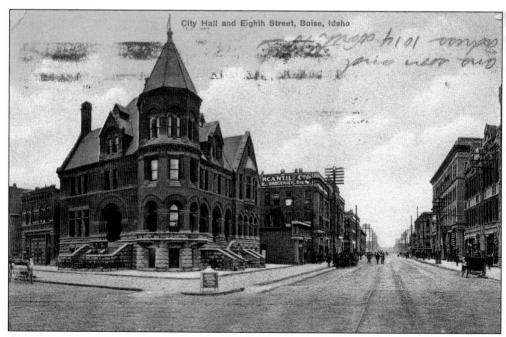

CITY HALL AND EIGHTH STREET, PRE-1910. The automobile at right dates this postcard to after 1906. A trolley can be seen going down Main Street. The Falk's sign is seen on the Falk's Building in the middle distance. The small building to the south now has a canopy.

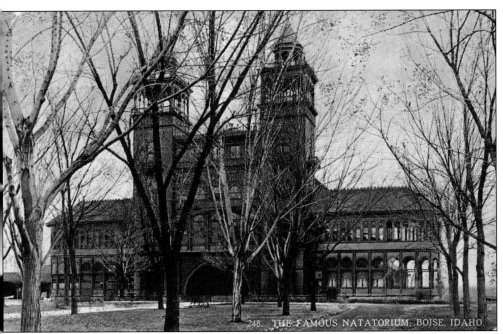

NATATORIUM, PRE-1910. The Natatorium, built in 1892 and fed by hot springs, included a 125-foot-long pool. It was located at the end of Warm Springs Avenue. The structure was built in a Morris Revival style. Over the years, steam caused the wooden beams to rot, and the roof collapsed in a windstorm in 1934. Many houses on Warm Springs Avenue used the geothermal source of hot water, and many still do today.

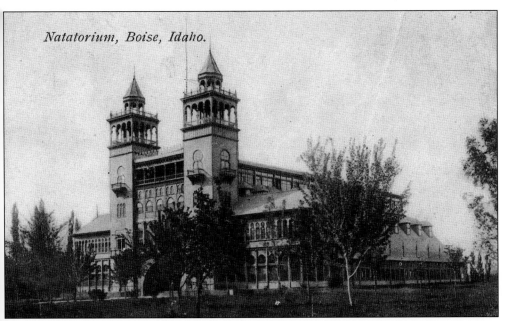

NATATORIUM, C. 1910. This view shows more of the west side of the building. A mezzanine ran around the entire pool, and the building also housed a gymnasium, dance hall, card rooms, baths, and tearooms. An artificial waterfall made of lava rock was over 40 feet high.

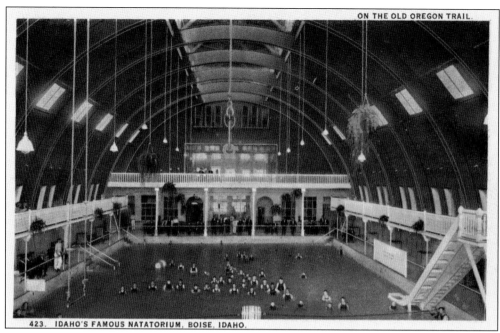

423. IDAHO'S FAMOUS NATATORIUM, BOISE, IDAHO.

NATATORIUM POOL, PRE-1920. The waterfall is on the opposite side, out of view. White City Amusement Park was located next to the pool and competed with Pierce Park for visitors. The park included dance halls, boating docks, arcades, and a wooden roller coaster. Today, Adams School stands next to the now uncovered pool.

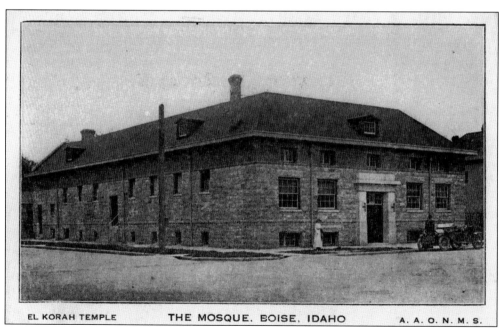

EL KORAH TEMPLE THE MOSQUE. BOISE, IDAHO A. A. O. N. M. S.

EL KORAH TEMPLE MOSQUE, 1920s. Located at 1118 Main Street, this temple was chartered in 1891 and built in 1914. It is the fifth-largest Shriners' temple in the Northwest. Still in use today, the building looks much the same as in this view.

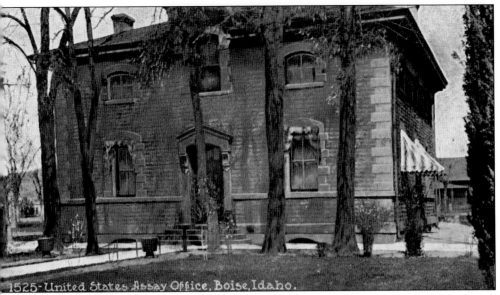

BOISE ASSAY OFFICE, PRE-1910. The nearest assay office at the time was in San Francisco; a closer facility was needed to support gold operations in the Boise Basin and in nearby areas. The office operated until 1933. It was at one time suggested for a branch mint. The Boise National Forest used the building as headquarters; today, it houses the Idaho Historical Society's State Historic Preservation Office and the Archaeological Survey of Idaho.

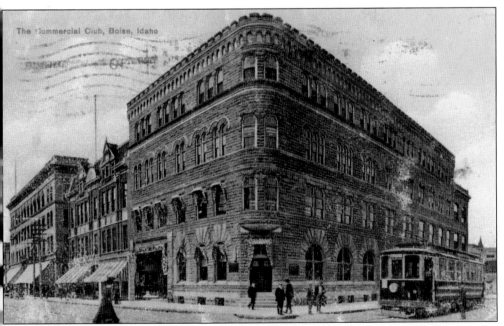

COMMERCIAL CLUB, C. 1910. This is a view looking north at Idaho and Eighth Streets. The structure at center was known as the Boise City National Bank Building. Erected in 1890, it was later used by the Idaho Power Company. At center left is the Odd Fellows Hall, built in 1899. At the far left is the Eastman Building, before two floors were added. It burned down in January 1987. The card is postmarked 1910. Only the Boise City National Bank building exists today.

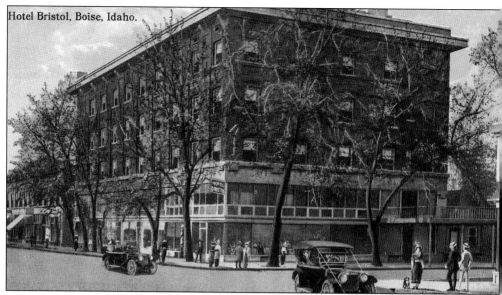

Hotel Bristol, Boise, Idaho.

BRISTOL HOTEL, 1920s. The Bristol Hotel, built in 1910, was also known as the Milner Hotel. It was located on the northwest corner of Grove and Tenth Streets. The location was later partially used for the Safari Inn's parking lot and a private parking lot. A new multistory apartment complex is planned for the site. At the time of the hotel's construction, it was just a couple of blocks north of the train depot.

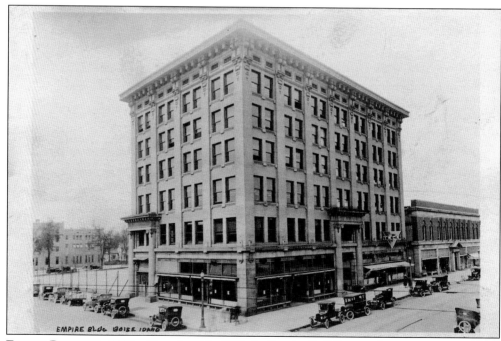

EMPIRE BLDG BOISE IDAHO

EMPIRE BUILDING, 1920s. Completed in 1912, the Empire Building was home to Kerr Hardware and Implement Co. Located at 205 North Tenth Street, the structure was later occupied by Idaho First National Bank as its corporate headquarters. An addition was built to the west in 1927. The YWCA also occupied the building for a few years. The Masonic Building is seen to the right.

EMPIRE BUILDING, C. 1912. This is a vertical view of the building. The YWCA sign is missing in this postcard. The building was constructed in the Chicago School/Commercial style. There was talk of tearing the building down in the 1990s, but public outcry was so intense that the structure was remodeled instead. While the building was originally constructed in a C-shaped pattern, its center section was filled in during a remodeling.

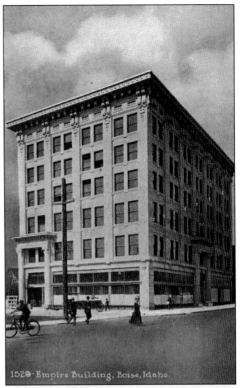

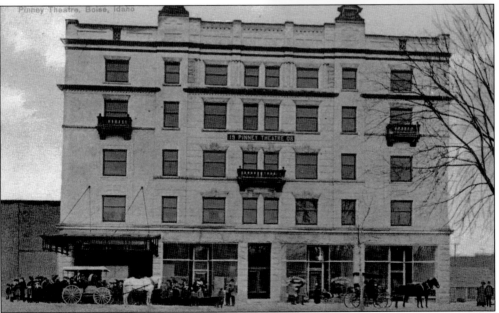

PINNEY THEATRE, PRE-1910. Built in 1908 across the street from the Columbia Theater, which was constructed in 1892, the Pinney was erected by James Pinney, who built the Columbia. Pinney was Boise's mayor when Idaho Territory became the state of Idaho in July 1890. The Pinney Theatre was located at 809 West Jefferson Street, between Eighth and Ninth Streets. It was torn down in 1969, and today the site is a parking lot.

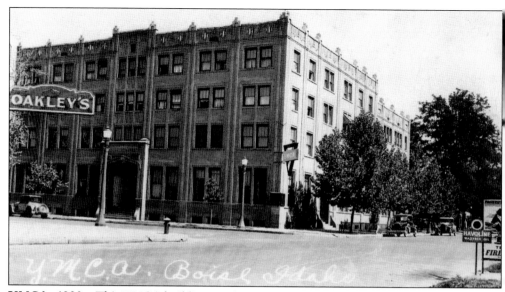

YMCA, 1920s. This YMCA building was located at 1104 Idaho Street. Construction of a new facility began in 1966 at 1050 State Street. Oakley's, now known as Oakley-Moody, is now located at 1375 Grove Street. The sign for a Texaco station is just visible on the far right.

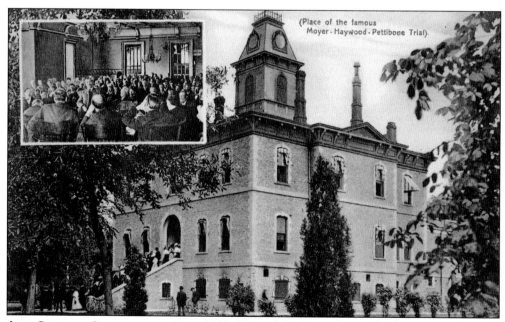

(Place of the famous Moyer-Haywood-Pettibone Trial).

ADA COUNTY COURTHOUSE, PRE-1910. The original courthouse, built in 1882, was later replaced by a new one in about the same location. In 1907, Boise became the center of national attention for the Haywood trial. Harry Orchard was convicted of killing former governor Frank Steunenberg. He placed the blame on William Haywood in 1907 for ordering the assassination. Famous attorney Clarence Darrow came to defend Haywood, and local attorney William Borah was the prosecutor. Borah later became a state legislator and then a senator from Idaho and was known as the "Lion of the Senate." Boise's second public high school and Idaho's highest peak are named for him.

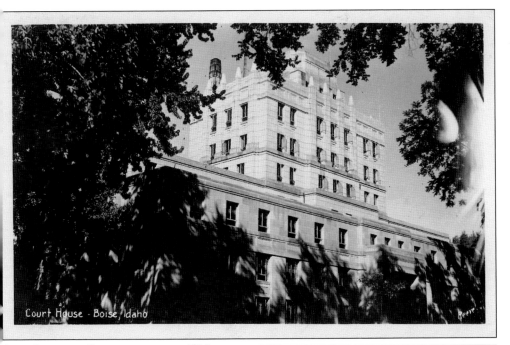

Court House - Boise, Idaho

ADA COUNTY COURTHOUSE, C. 1930s.
This Art Deco building was completed in
1939. The first four floors were built of
Indiana limestone. The upper floors were
used as the county jail. In August 2010, the
University of Idaho chose the old courthouse
as the future home of its Boise law program.
A new courthouse was opened at 200 West
Front Street in February 2002.

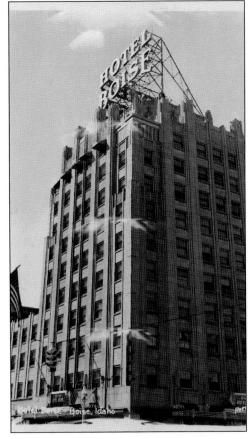

HOTEL BOISE, C. 1930s. This hotel, finished
in 1931, was the first building in Boise
over 10 stories tall. A large, red illuminated
sign was added to the building shortly after
opening. Singer Roger Miller said he wrote
most of his hit "King of the Road" while
visiting Boise. Some have reported that he
was at the Idanha Hotel, but a story covered
by one of the Boise television stations stated
that Miller was at the Hotel Boise, even
showing the door to his room. KIDO radio
operated from the ninth floor of the hotel
and mezzanine for several years. The KIDO
sign can be seen on the lower corner of the
building. The hotel was later remodeled,
and a couple of floors were added. It is now
known as the Hoff Building.

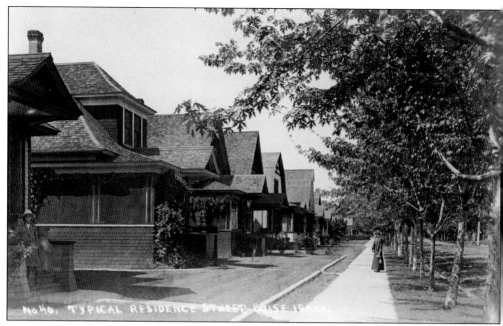

"Typical Residence Street," Pre-1910. Most Boise neighborhoods looked like this after 1900. Pictured here is a sidewalk with a strip of grass between it and the street. Later neighborhoods had their sidewalks up to the street. Many of the newer neighborhoods have winding sidewalks, with grass between them and the streets.

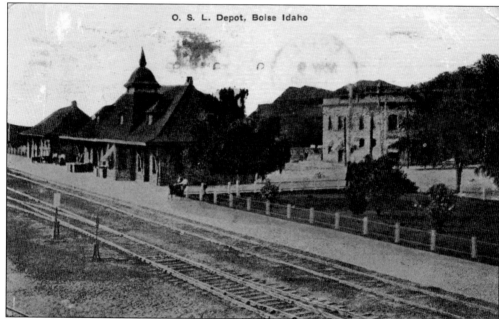

OSL Depot, Postmarked 1912. Boise's second train depot was built in 1893 or 1895 at Tenth and Front Streets. Made of sunstone, the station had a cupola resembling a Prussian helmet. The Oregon Short Line, a division of Union Pacific, built a railroad line across southern Idaho in 1883–1886, but it bypassed Boise. The main line ran from Mountain Home to Kuna, then to Nampa. In 1887, a line from Nampa was completed to Boise.

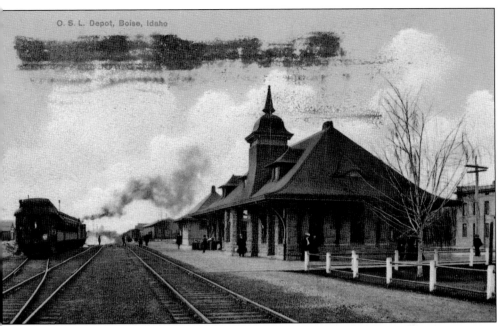

OSL Depot, Pre-1915. All of the buildings in this view, except for the one on the far right, are gone. The depot was replaced in 1925 and used as an office and freight depot. It was torn down in 1947. The tracks downtown were removed in the early 1980s. This area was used for parking for several years.

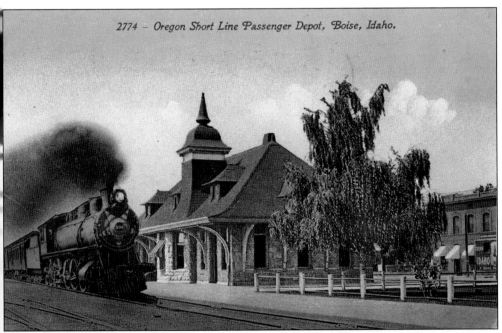

OSL Passenger Depot, Pre-1915. The building on the far right was the powerhouse. Today, it is used for concerts. Locomotive no. 306 appears on Oregon Short Line's roster. A small portion of the depot park can be seen on the right.

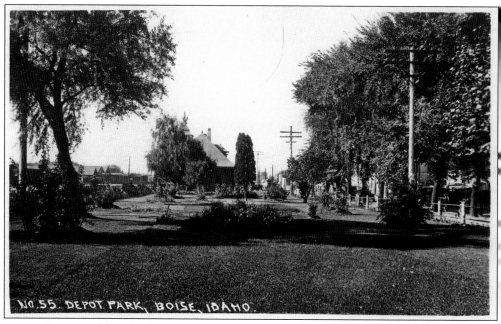

DEPOT PARK, 1920s. The depot is in the background, and automobiles can be seen parked on the right. Telephone/power poles are present in the area.

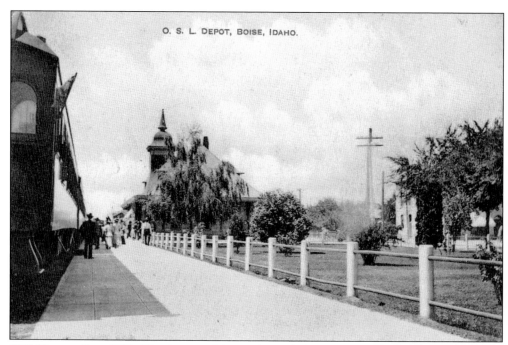

OSL DEPOT, PRE-1920. The depot park is at right, with the depot in the background. Passengers are seen getting ready to board a train.

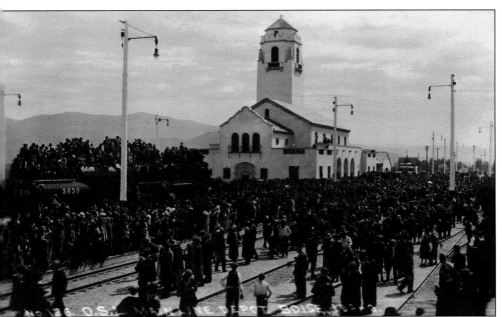

OSL Main Line Depot, April 24, 1925. The new depot's grand opening is shown here. In 1923–1924, Union Pacific ran a line from Orchard to Boise to Nampa, connecting Boise to the main line. The depot, probably Boise's second-most famous building, stands at the end of Capitol Boulevard. The last passenger service, via the Pioneer, was in 1997. Morrison Knudsen bought the station in 1990 and restored it to its original condition. The company sold it to the City of Boise in 1996. This view is from the back of the station.

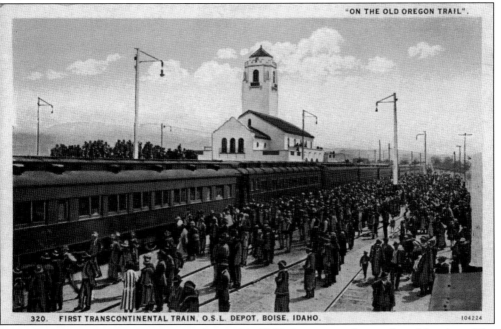

First Transcontinental Train, April 24, 1925. Large crowds attend a celebration of the first transcontinental train into Boise. This view is from the back of the station. Shaw Mountain/ Lucky Peak can be seen in the background.

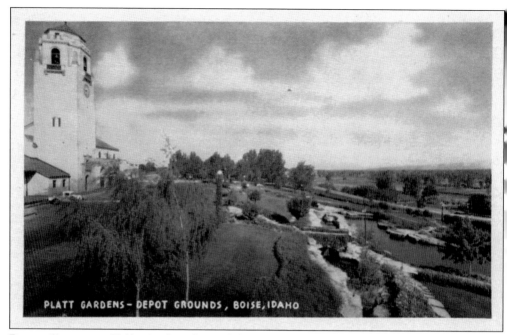

PLATT GARDENS, 1940s. Built in front of the Boise Depot in 1927, the area covers seven acres. It has fishponds, walkways, a monument made of volcanic rock, benches, and flora. The City of Boise was given the land by Union Pacific Railroad in 1982. It is a great location to view downtown Boise. Many wedding pictures are taken there today.

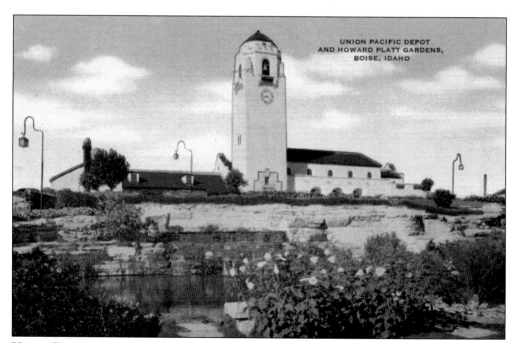

UNION PACIFIC DEPOT, 1940s. This view of the depot has appeared on many postcards since its construction in 1925. The top of the tower portion is open to the public by either stairs or elevator on certain days of the week.

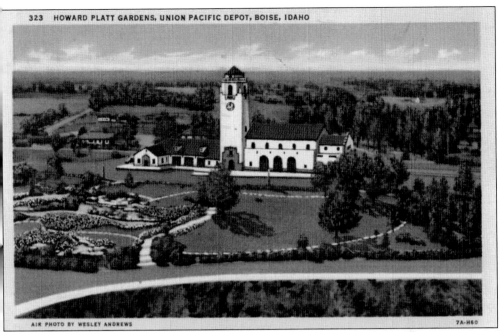

AIR PHOTO BY WESLEY ANDREWS 7A-H60

AERIAL VIEW OF THE DEPOT, POSTMARKED 1946. The land behind the depot looks nothing like this today, as it has been filled in with residences. The street on the far left is probably Vista Avenue, a major business thoroughfare that connects downtown (via Capitol Boulevard) to the airport.

Boise's canteen for servicemen at the Union Pacific depot where Red Cross workers serve refreshments to soldiers, sailors and marines pausing in the city between trains. The canteen is supplied alternately by members of Boise women's organizations.

CANTEEN AT BOISE DEPOT, 1941–1945. The canteen at the depot was set up for servicemen during World War II. It was located on the south side of the depot. Gowen Field was leased by the city to the Army Air Corps for a training base.

101

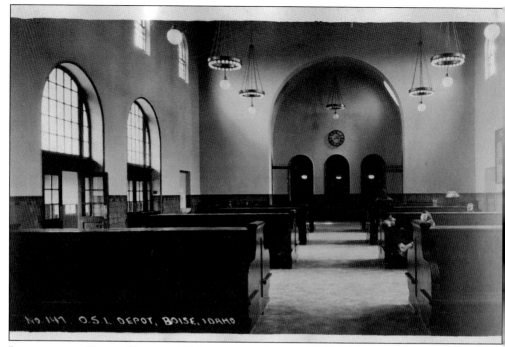

INTERIOR OF TRAIN DEPOT, 1930S–1940S. The opposite side of the lobby had a gift shop. This area now contains historical displays. The lobby is open to functions through the Boise Parks system. The tower is open to the public on certain days.

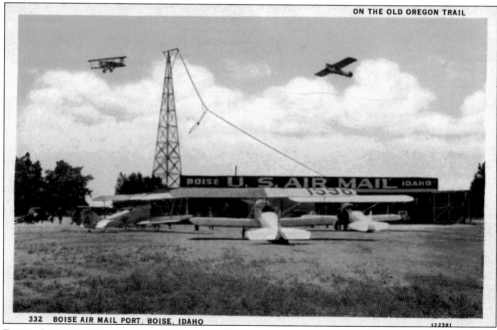

BOISE AIRMAIL PORT, LATE 1920S. Boise's first airport was located off Broadway, about where Boise State University's stadium is today. Varney Air Service, which became United Airlines, started here. The airport was moved south of Boise to what is known as Gowen Field in 1936.

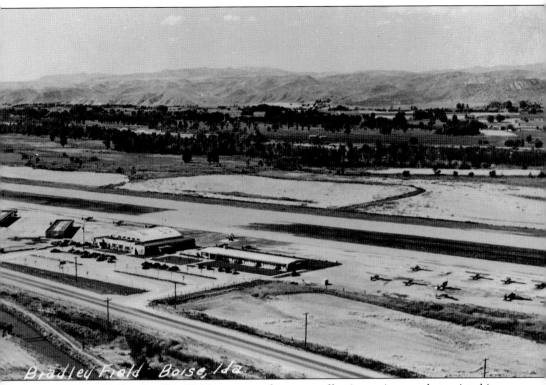

Bradley Field - Boise, Ida.

BRADLEY FIELD, 1940s. Bradley Field was one of many small private airports that existed in Boise at one time. It was located northwest of the city and operated from 1946 to 1973.

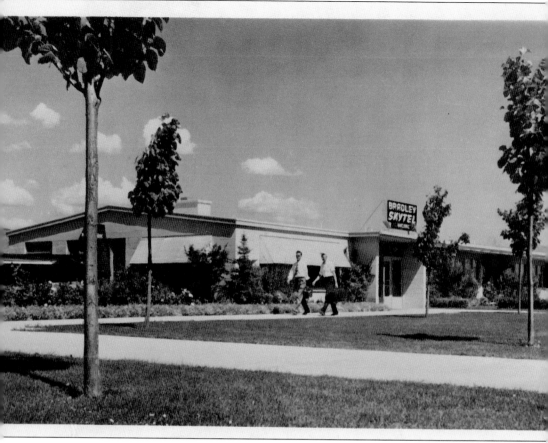

BRADLEY SKYTEL, 1940s. A motel was located at Bradley Field for several years. Today, Gowen Field has facilities for all private aircraft in the Boise area.

Nine

STATE CAPITOL

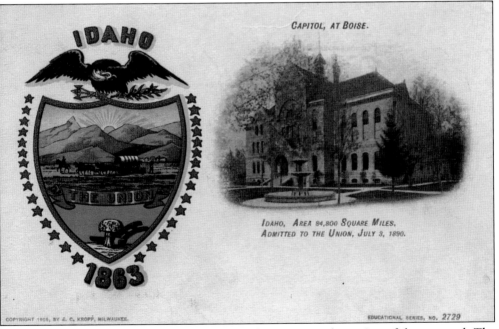

CAPITOL AT BOISE, PRE-1906. This postcard features an early version of the state seal. The building shown here served as the territory's capitol and then the state capitol from 1890. It was torn down by 1906 to make room for the new capitol.

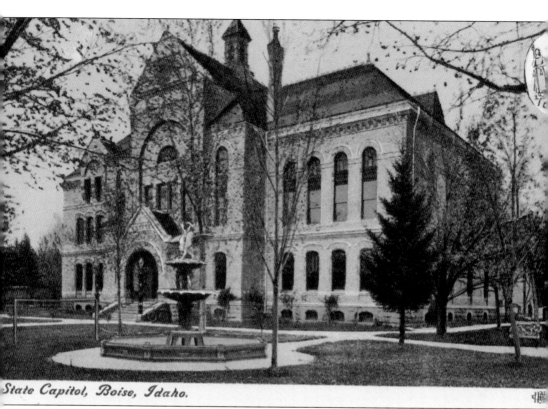

State Capitol, Boise, Idaho.

STATE CAPITOL, PRE-1906. This postcard includes the updated state seal. Note the fountain in front. This building was erected in 1885 and 1886. This was the first capitol building constructed in Boise. Lewiston was the territorial capital for a short period.

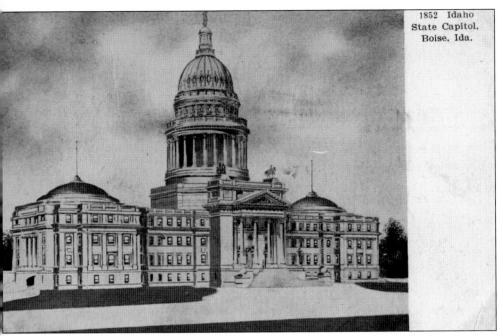

STATE CAPITOL, C. 1906. This is a line drawing of the planned capitol building. The central section was started in 1906. The center tower section is a little out of proportion.

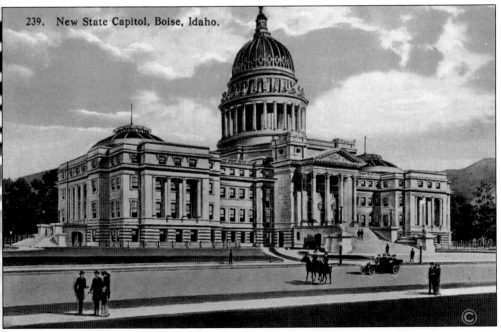

239. New State Capitol, Boise, Idaho.

NEW STATE CAPITOL, C. 1914. Additional wings were added in 1920. This is an accurate depiction of what the capitol looked like after 1920—and how the structure looks today. Note the automobile in front.

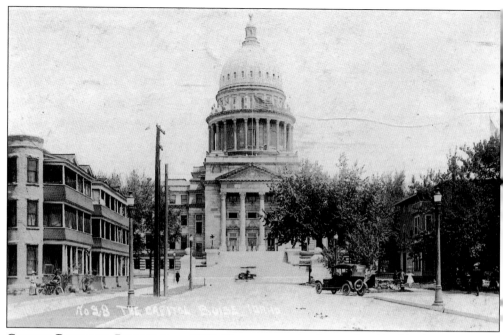

CAPITOL BUILDING, POSTMARKED 1918. The center section is completed in this view. Apartment buildings are located in front along the street. They were later torn down, and a new park was created on the right side.

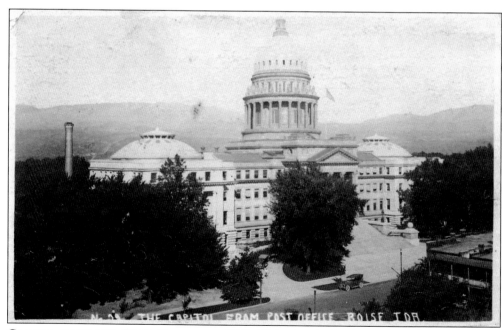

CAPITOL FROM THE POST OFFICE, C. 1920. This view looks down from the Post Office/Federal Building. The building on the right was torn down, and the smokestack in the back is also gone.

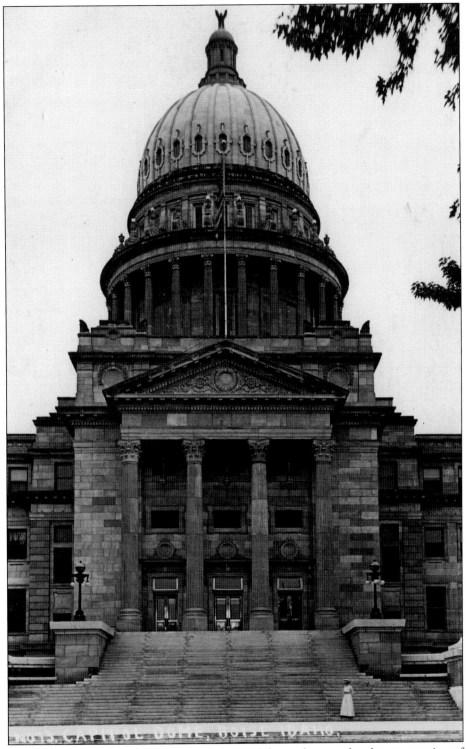

CAPITOL DOME, PRE-1910. This vertical postcard shows the completed center section of the capitol building.

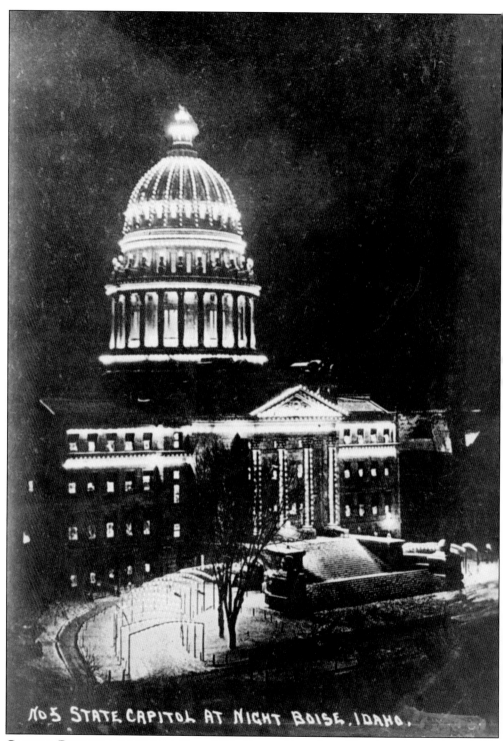

CAPITOL BUILDING AT NIGHT, PRE-1910. Pictured here is an illuminated capitol, probably for Christmas, as there appears to be snow on the ground. Only the center section has been completed at this time.

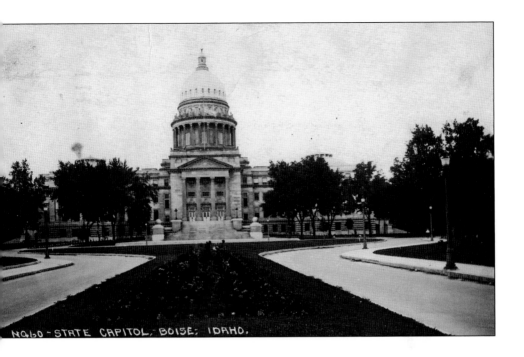

NO.60 - STATE CAPITOL, BOISE, IDAHO.

CAPITOL BUILDING FROM THE FRONT, 1920s. Construction began in 1905 on the central portion and dome, which rises 208 feet into the sky. The only difference among these three views are the floral arrangements in the front. The third view (on page 112) has the dome a golden color. Several early views depict the dome this way, although it never appeared as such in reality.

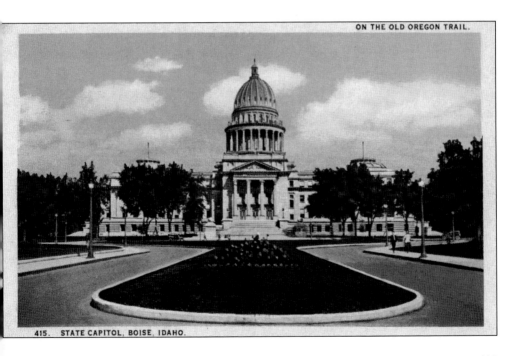

ON THE OLD OREGON TRAIL.

415. STATE CAPITOL, BOISE, IDAHO.

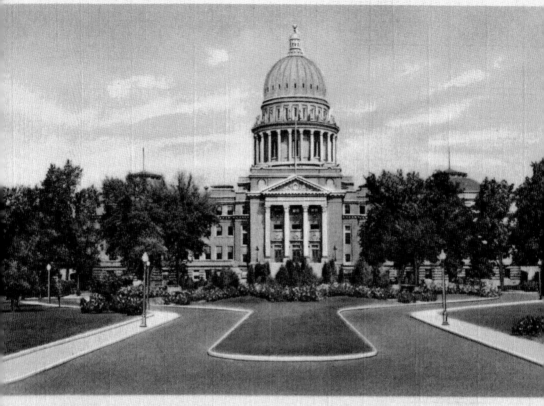

STATE CAPITOL, 1930s. Here is a view of the state capitol with the landscaped garden in front of it, on State Street.

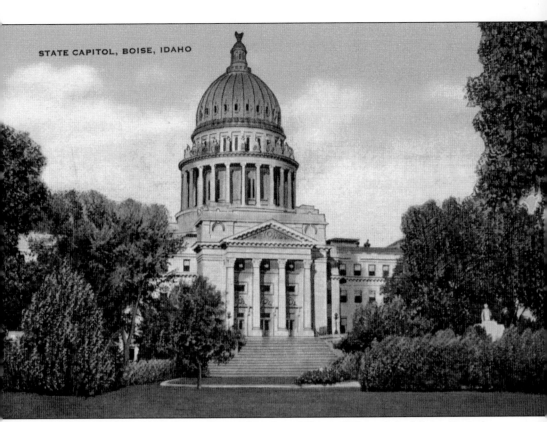

STATE CAPITOL, BOISE, IDAHO

STATE CAPITOL, 1930s. The back of this card reads as follows: "The original State Capitol at Boise was built in 1885. In 1905, the Capitol Building was authorized for legislative, executive, and judicial purposes at a cost of one million dollars. Building continued from 1906–1912. The east and west wings were erected in 1919–1920 at a cost of 2,290,000." This view is deceptive, as it shows just lawn in front of the building. In reality, the steps go down to State Street.

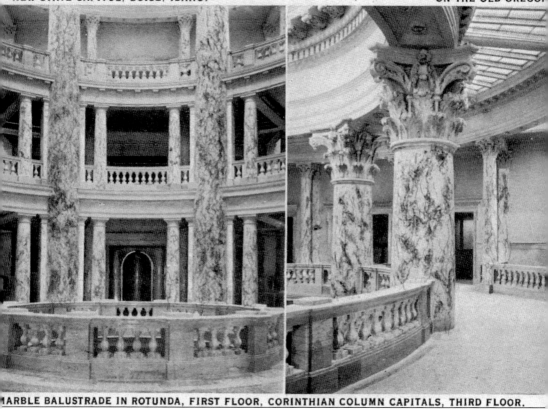

MARBLE BALUSTRADE IN ROTUNDA, FIRST FLOOR, CORINTHIAN COLUMN CAPITALS, THIRD FLOOR.

NEW STATE CAPITOL, C. 1920S. Here are two inside views of the capitol. At left is "Marble Balustrade in Rotunda, First Floor." The right side shows "Corinthian Column Capitals, Third Floor." The marble used came from Georgia, Alaska, Vermont, and Italy.

Ten

ARROWROCK DAM

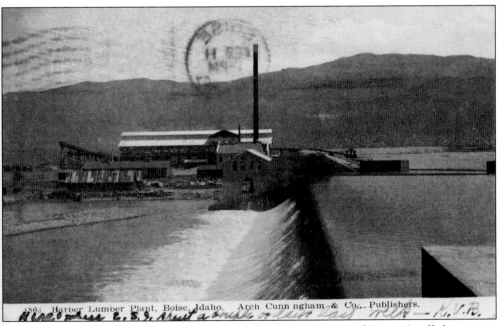

BARBER LUMBER PLANT, C. 1907. This facility was built east of Boise. Small dams were installed on the Boise River east of town to support lumber mills and to divert water into canals to provide irrigation for the valley.

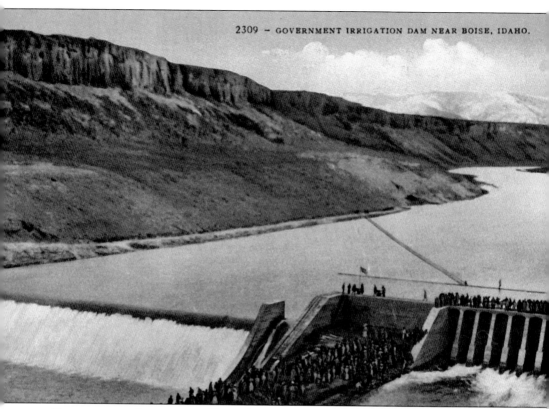

GOVERNMENT IRRIGATION DAM, PRE-1920. Known as Diversion Dam, this was built in 1909. A power plant was added in 1912, to divert water into the New York Canal, which runs to south of Nampa and flows into Lake Lowell. A network of canals diverted flow from the New York Canal to supply water to the Boise Valley.

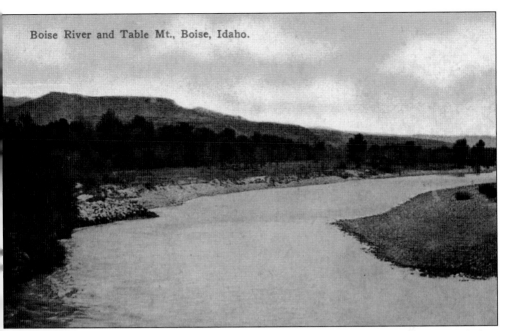

Boise River and Table Mt., Boise, Idaho.

BOISE RIVER AND TABLE MOUNTAIN, PRE-1920S. The Boise River is shown here below what is actually known as Table Rock, not "Table Mountain," as stated in the caption. It rises to an altitude of 3,629 feet. The city lies at about 2,700 feet. Sandstone from Table Rock was used in the first buildings in Boise. Table Rock today is a popular hiking area.

IRRIGATING DITCH.

SOUVENIR OF BOISE, IDAHO.

Publ. by Faust's Art Store. Photo by S. C. Lee.

IRRIGATION DITCH, C. 1900. After the construction of small dams on the Boise River east of town, ditches and canals were created to supply water for agriculture in the Boise Valley. Many farms and ranches were able to prosper in both Ada and Canyon Counties. Idaho has become one of the leaders in the dairy industry today. It is interesting to think that a card showing a ditch would be considered a souvenir, as implied by the caption on the left of the card.

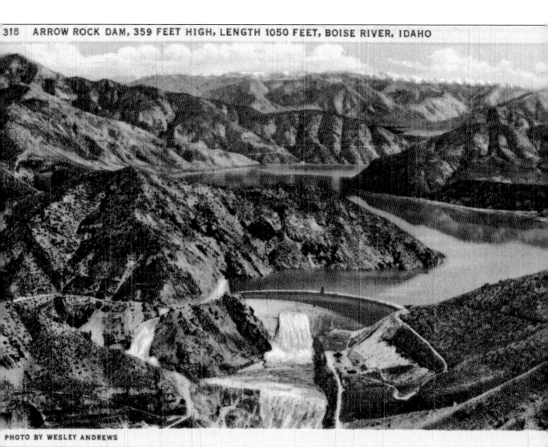

PHOTO BY WESLEY ANDREWS

AERIAL VIEW OF ARROWROCK DAM, 1930s. The Arrowrock Dam was built 20 miles east of Boise on the Boise River. At an elevation of 3,219 feet, it was one of the highest dams in the world at the time.

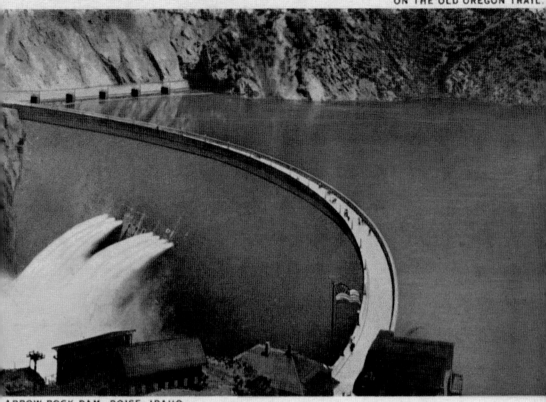

ARROW ROCK DAM, BOISE, IDAHO.

ARROWROCK DAM, 1940s. Text on the back of this card reads, "Twenty Miles from Boise, on the Union Pacific System built by the US Government at a cost of approximately $5,000,000." Construction on the dam started in 1912 and was completed in 1915. Height 348.5 ft., 90 feet of which is below bed of rover, anchored in solid granite. Base 240 feet thick, top 1,100 feet long and 15 feet thick. Driveway around the top. Material in dam weighs 1,000,000 tons. Maximum depth of water back of dam is 260 feet. Backwater forms lake 18 miles long. Designed to irrigate 240,000 acres of land."

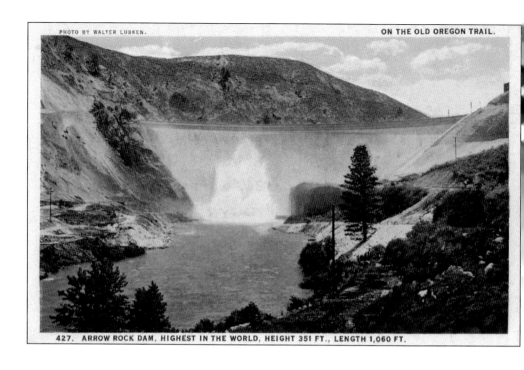

427. ARROW ROCK DAM, HIGHEST IN THE WORLD, HEIGHT 351 FT., LENGTH 1,060 FT.

VIEWS OF ARROWROCK DAM, 1920s–1940s. Dams to supply power for the Boise area were first built on the Snake River.

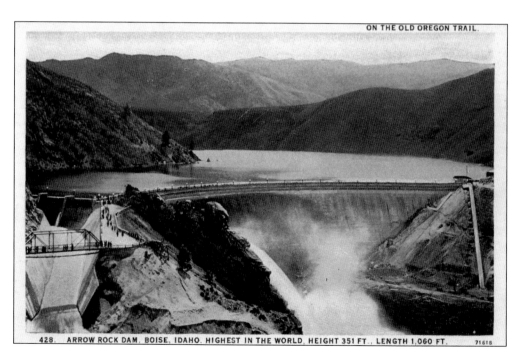

428. ARROW ROCK DAM, BOISE, IDAHO. HIGHEST IN THE WORLD, HEIGHT 351 FT., LENGTH 1,060 FT. 71618

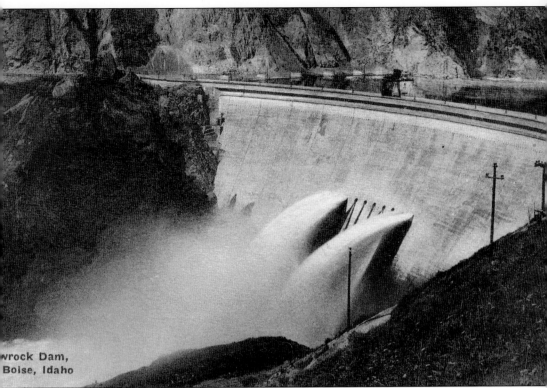

wrock Dam,
Boise, Idaho

FRONT VIEW OF ARROWROCK DAM, LOOKING FROM THE SOUTH. Lucky Peak Dam was built on the Boise River west of Arrowrock Dam in 1955 to provide electricity.

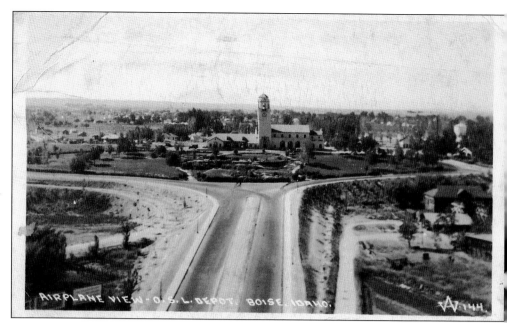

AIRPLANE VIEW OF DEPOT, LATE 1930s–EARLY 1940s. The areas on both sides of Capitol Boulevard are developed today. Note that, in this card, postmarked 1943, no automobiles are seen on Capitol Boulevard. The water tower on the right side no longer exists. The open area behind depot is developed today, with both commercial and residential buildings.

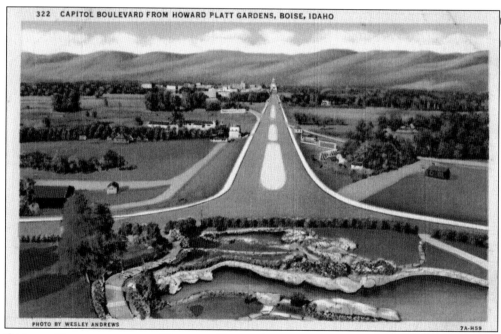

CAPITOL BOULEVARD FROM HOWARD PLATT GARDENS, 1930s. This is a color-tinted view looking north toward the capitol building from the train depot. The large open area to the upper right is now the location of Boise State University. Areas to the immediate left and right of Capitol Boulevard have been doctored in this postcard.

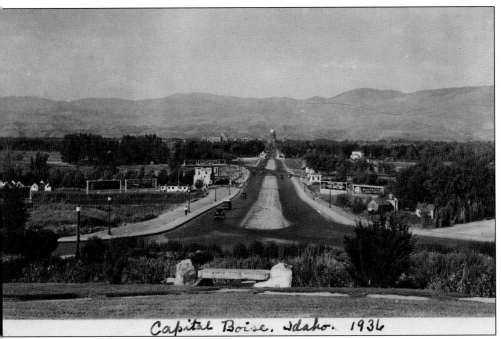

Capital Boise. Idaho. 1936

CAPITOL BOULEVARD, LOOKING NORTH, 1930S. The handwritten caption at the bottom of this card has the year 1936. Billboards are present on both sides of Capitol Boulevard. One on the far right is for Boise Payette Lumber Company, which is today Boise Cascade Company. One on the left appears to have a Texaco logo on it.

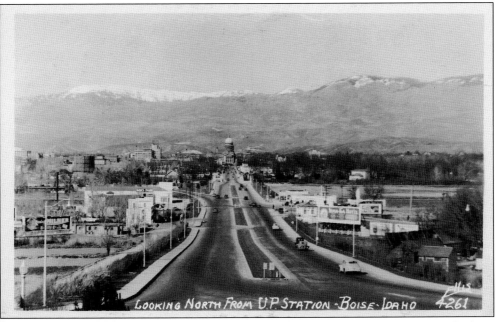

LOOKING NORTH FROM U.P. STATION · BOISE · IDAHO

CAPITOL BOULEVARD, LOOKING NORTH, MID-1940S. At left is a water tower, which no longer exists. Bob's Travelers Park is seen on the left side of Capitol Boulevard. On the far right is the top of the Ada County Courthouse. This photograph was taken in spring or fall, as there is snow on the Boise Front Range.

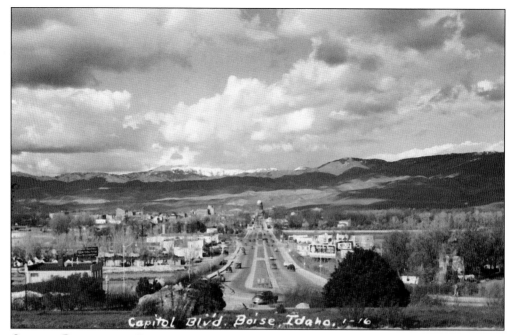

Capitol Boulevard, Looking North, Late 1940s. In this view, the water tower appears to be gone. Baxter's Industrial is now seen on the far left. The billboard for Idanha Hotel (spelled Idanha-ha) is still on the right side of the boulevard. This is a much sharper view than that in the previous card.

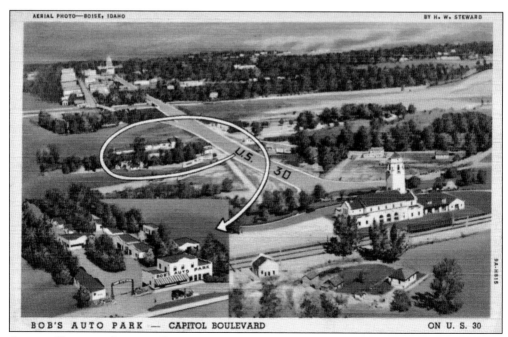

Aerial View of Capitol Boulevard, Late 1930s. This is an advertising card for Bob's Auto Park, "Largest in Idaho, Fifty Cabins." The location is now a different motel. The open area at center is now the site of Boise State University. This view is to the northeast.

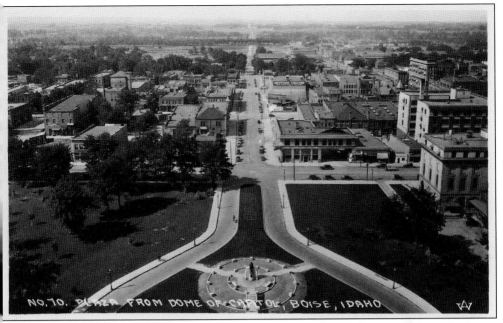

PLAZA FROM CAPITOL DOME, PRE-1931. This view looks south toward the train depot. Memorial Bridge across the Boise River has yet to be built. There is a sign for the Egyptian Theatre on the back of a building right of center. Many of the structures seen here are now gone. The statue of Gov. Frank Steunenberg is at the bottom.

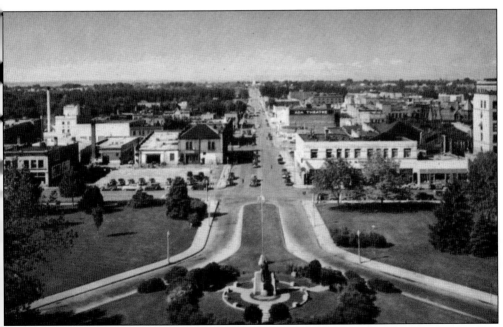

BOISE FROM CAPITOL DOME, MID-1930S. This postcard offers the same view as the one above, but the Egyptian Theatre is now the Ada Theatre. Today, it is again called the Egyptian Theatre. The lot on the left with automobiles parked in it is today the site of the Telephone Central Office, built in the later 1930s. Trees now circle the Steunenberg statue.

"THE SKIPPER FONDLES THOSE IDAHO POTATOES AS THOUGH THE WAR DEPENDED ON 'EM!"

GOWEN FIELD AMRY AIR CORPS BASE, 1940s. After the airport was moved to the south of Boise, it became, and still is, a joint civilian and military facility. Boise bought and leased land for the present airport in 1936–1938. It had the nation's longest runway at the time, 8,000 feet. Gowen Field operated as an Army Air Corps base during World War II and was used as a training base for B-17 and B-24 bombers. Actor Jimmy Stewart trained there during the war and would come into town and play the organ at the Ada Theatre. Today, the Idaho Air National Guard uses the facility. In 2012, the commercial airport at Gowen Field ranked 78th in the nation for passenger numbers. A major remodeling of the commercial airport was finished in 2005.

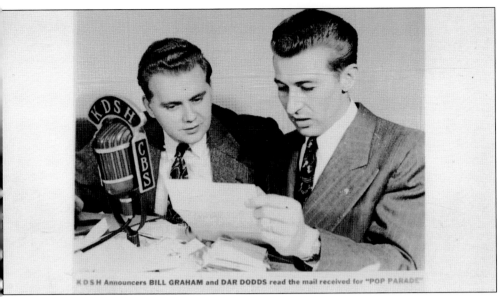

KDSH Announcers BILL GRAHAM and DAR DODDS read the mail received for "POP PARADE"

KDSH Radio Card, Late 1940s. KDSH was the sixth radio station to come on the air in the Boise area, in 1946. The first station was KFAU, now KIDO. (See *Boise's First Radio Station* by Art Gregory, published by Arcadia.) It came on the air in 1922. Later, three short-lived stations were on the air in the early 1920s. INB debuted in 1946, KGEM came on the air, then KDSH in 1947. In 1955, KDSH became KBOI when the Federal Communications Commission approved the transfer of the license of KDSH's television station (KBOI) from the City of Meridian to the City of Boise. Bill Gratton was a leading radio personality and newscaster for KBOI-TV and radio for many years. Dar Dodds hosted several of KBOI's radio programs. Sadly, neither of them is still alive. KBOI was the first radio station in Idaho to go to 50,000 watts.

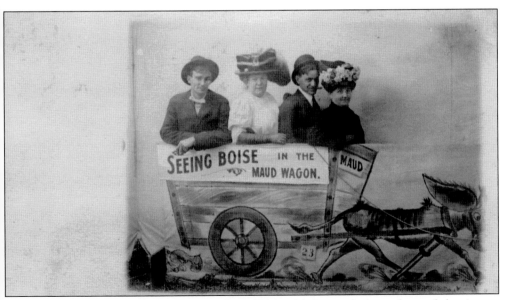

Seeing Boise in the Maud Wagon, Pre-1905. This is a typical novelty card that is seen even today. Note that the mule/donkey has what appears to be a wooden leg. Many early cards featured an area on the front for writing messages.

DISCOVER THOUSANDS OF LOCAL HISTORY BOOKS FEATURING MILLIONS OF VINTAGE IMAGES

Arcadia Publishing, the leading local history publisher in the United States, is committed to making history accessible and meaningful through publishing books that celebrate and preserve the heritage of America's people and places.

Find more books like this at
www.arcadiapublishing.com

Search for your hometown history, your old stomping grounds, and even your favorite sports team.